OFF-CAMERA FLASH

Techniques for
Digital Photographers

Neil van Niekerk

AMHERST MEDIA, INC. ■ BUFFALO, NY

ABOUT THE AUTHOR

Neil van Niekerk, originally from Johannesburg, South Africa, is a wedding and portrait photographer based in northern New Jersey. He graduated with a college degree in electronic engineering and worked as a television broadcast engineer in South Africa (while pursuing photography as a parallel career) before deciding to settle in the United States in 2000. Says Neil, "I love photography for a variety of reasons. The stimulation and excitement of responding to new situations satisfies both my analytical and creative sides, and I also truly love working with people. I get real pleasure from sharing the happiness with the people that I photograph and knowing that I'm creating images that will evoke wonderful memories for a lifetime." His "Planet Neil" web site (www.planetneil.com) has become a popular destination for photographers seeking information on the latest equipment and techniques. Visit www.neilvn.com to see more of Neil's photography.

Published by:
Amherst Media, Inc.
P.O. Box 586
Buffalo, N.Y. 14226
Fax: 716-874-4508
www.AmherstMedia.com

Publisher: Craig Alesse
Senior Editor/Production Manager: Michelle Perkins
Assistant Editor: Barbara A. Lynch-Johnt
Editorial Assistance from: Chris Gallant, Sally Jarzab, John S. Loder

ISBN-13: 978-1-60895-278-6
Library of Congress Control Number: 2010940483
Printed in The United States of America.
10 9 8 7 6 5 4 3 2 1

Check out Amherst Media's blogs at: http://portrait-photographer.blogspot.com/
http://weddingphotographer-amherstmedia.blogspot.com/

Table of Contents

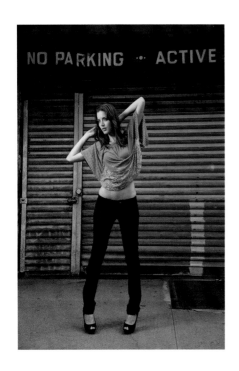

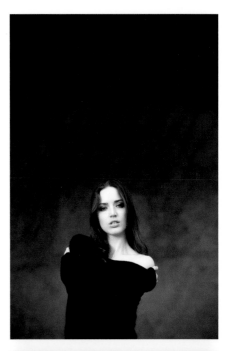

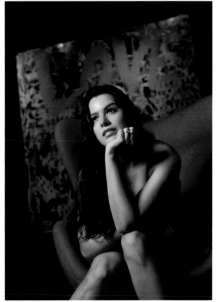

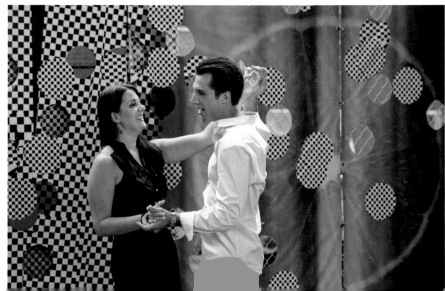

Foreword

When my friend Neil asked me to write the foreword to his new book, I started to think about all the things we have in common and how many points we disagree on. In truth, that's what I think makes art wonderful: there is always a diverse abundance of opinions and thoughts.

However, the one thing that Neil and I wholeheartedly agree on is the importance of light. Light is the essential ingredient to any good photograph. It is what usually makes a photograph interesting. Any good photographer will know how to see, shape, and use it to achieve their desired photograph and vision.

When I started making photographs some twenty-five years ago, it was about composition and subject. That was all I thought about. It wasn't until years later I really started to "see" light. In retrospect, I think I was always able to see the light, but I was not educated enough to understand why my images looked the way they did.

In my conversations with Neil about photography, we've often talked about light and how we are inspired by what it does to the subject we are viewing. Perhaps you too have seen an interesting pattern of light that falls across a wall or sidewalk. We get excited by the different effects it has in creating a mood, feeling, and look. Like us, you might have wondered how cool it would be to put a subject in that interesting play of light. This is when the photographic process gets interesting.

Just like many of you reading this, Neil and I are people photographers. To succeed at this, it is very important to understand existing light and the addition of artificial light. I see interesting shapes and patterns of light almost every minute of the day. The challenge with photographing people is learning how to put a person within an environment that I am intrigued by and get them to blend in or stand out—to become a part of the vision I see in my head. To me, this is the beginning of the learning process.

A question I am often asked by photographers is, "Can you teach me how to use my lights?" I also hear, "I'm a natural-light photographer, I don't need a flash. Your images are way cool, though—how do you get that?" Using an off-camera flash is really quite simple—and a greater understanding of exposure and lighting will allow you to create your own vision. Neil is exceptional at explaining how to do things with light. He is able to take the mystery out of lighting and make it attainable by everyone.

My advice to you is to read this book carefully and then go shoot. And get up the next day and go shoot some more. Repeat these steps until you die. Be sure to make the effort to practice. Don't expect to just "get it." With anything in life, you have to practice to get better. When I was learning, almost every night I would take my wife up and down our neighborhood and photograph her. We were having fun. I took notes and when I got my film back, I would study what we did and how light wrapped around a form. I shot with many small light sources and large light sources coming from all kinds of places. (Just like some of the light sources discussed in this book.) It was a blast—and it still is.

I find myself writing this in the early part of the morning, and the light is amazing right now. I'm going to go practice some more. I encourage you to take what you learn in this book and do the same.

—Chuck Ärlund
www.chuckarlund.com

Introduction

There are numerous resources out there that explain the hardware part of lighting—the clamps, stands, cables, flashes, and light modifiers. Sometimes, lighting even seems to be *just* about the toys. While we do have to cover the types of lighting equipment we'll need, in this book I wanted to take a different approach—one that is less gear-centric.

With the workshops I have presented, and the questions I've answered on my web site, I frequently see an underlying hesitation. Photographers don't quite know where to start. They have a subject and they are in a specific location . . . but they have no clear idea how to proceed. For the most part, these photographers seem to be daunted by three things when it comes to off-camera lighting:

1. What should I set my camera to?
2. What should my flash settings be?
3. Where should I place my light(s)?

We will look at how to use off-camera flash in specific situations photographers may find themselves in.

Instead of looking at flash photography in relation to various bits of equipment and hardware, most of this book will be devoted to answering those important questions. We will look at *how* to use off-camera flash in specific situations photographers may find themselves in. Reading this book should be like having a tutor right there next to you—talking to you and explaining the various aspects of off-camera flash photography.

The final chapter of the book brings it all together, looking at several different photo sessions during which different techniques were used. We will go over the thought process to see how everything meshes on location.

Given that the entire premise of this book is to make off-camera flash accessible to anyone, we will mostly look at using just one off-camera flash, instead of multiple light sources. As a start, though, let's see why we would want to use off-camera flash in the first place.

1. Why Use Off-Camera Flash?

Why use off-camera flash? We don't necessarily just use flash to avoid camera shake and/or poor exposure in low light. What is more important is that, with flash, we can control the direction and quality of light. Therefore, we can use flash to create better, more dynamic lighting on our subject. We can also "clean up" the available light that falls on our subject. Even when the light is soft, we can use off-camera flash to add a punchy look to our photos. It is about control—that's it in a nutshell!

IMPROVING OUR SUBJECT'S APPEARANCE

While on the topic of control, we do well to control our photo session in all aspects. In addition to the lighting, we need to control how we frame our subject against the background, and how we place our subject in relation to the available light. A typical snapshot, where we don't take much care in how we place our subject, would look like **image 1-1**. If we look at our model's features here, you will see that the lighting is uneven. The sun is creating strong shadows on her face. Hard sun is even more difficult to work with when it's overhead.

Without using any kind of additional lighting, we can achieve softer light just by placing our subject against the hard light. To create **image 1-2**, I had the model turn her back toward the sun. The light on her is now scattered, reflecting back from the sky—and, therefore, it is soft. To get an accurate exposure on the subject, however, we do lose detail in the much brighter background.

If we just use direct on-camera flash to bring the exposure of our foreground subject (our model), closer to the background, we get flat, hard lighting—as seen in **image 1-3**. This isn't as flattering as the light in the photo above where only available light was used.

When we take our flash off-camera, we create a more dynamic light pattern on our model's face (**image 1-4**). It accentuates the form and shape of her features—and the photograph just looks more interesting. For this photograph, a flashgun was used with a 24x24-inch softbox, a larger light source that produces a softer effect than unmodified flash.

While we could have used direct, on-camera flash as a fill flash in this scenario, it would only have lifted the shadows. Adding fill flash wouldn't have created a dynamic lighting pattern on our subject, so we would still have been

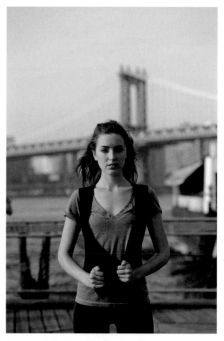

Image 1-1. A typical snapshot.

Image 1-2. The model turned her back toward the sun. This image was shot with the ambient light only. ($^1/_{250}$ second, f/4, 200 ISO)

Image 1-3. Adding direct, on-camera flash creates flat, hard lighting. ($^1/_{1000}$ second, f/4, 200 ISO)

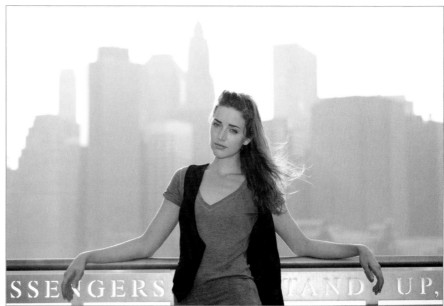

Image 1-4. Using off-camera flash creates a more flattering image. ($^1/_{1000}$ second, f/4, 200 ISO)

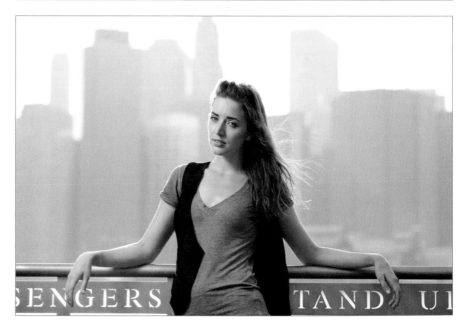

If the transition between the shadow and highlights is sudden, meaning it takes places over a small area, then the light is described as "hard." If the transition between the shadow and highlights is gradual, meaning it takes place over a larger area, then the light is described as being "soft." This transition is called the "shadow edge transfer."

Soft light is produced by light sources that are large in relation to our subject; hard light is produced by light sources that are small in relation to our subject. For example, the softbox used in **image 1-4** created softer shadows than the direct flash used in **image 1-3**. With the large softbox, there is a more gradual change between the highlights (the well-lit areas) and the shaded areas of the subject than with the small, unmodified flash.

This hard or soft aspect of light is the very thing that gives form, shape, and texture to our subjects when we look at a photograph.

limited by how the available light appeared. We were definitely better off using off-camera flash—in this case, specifically with a softbox.

CONTROLLING THE BACKGROUND

When it is within my control, I am quite particular about the backgrounds in my photos. The background needs to add something to it. For example, I prefer out-of-focus backgrounds that create separation and help my subjects pop out.

When I use only available light during a photo session, I am reliant on finding both a good background *and* great light on my subjects' features. When using supplementary lighting, the pressure is off. I pretty much just have to find a nice background, position my subject, and then use off-camera lighting to illuminate them properly. With the addition of off-camera flash, the photo session has just become much simpler.

Images 1-5 through **1-8**, from a photo session with Jill and Mike, are a good example. I began with a straightforward portrait of the couple against a background I knew would work (the sun-soaked leaves in the back would cre-

ate a golden glow behind them). Unfortunately, posed beneath a wooden archway overgrown with plants, the light on *them* wasn't flattering. The light was top-heavy and created dark shadows under their eyes. Therefore, I needed additional lighting.

To create **image 1-5**, my flash was in TTL mode and fitted with a softbox. (In my opinion, that intersection between "best light" and "simplicity" is around the point where you use an off-camera flash in a softbox.) My camera settings were chosen for the background, which I wanted to appear exactly as it did to my eyes. I then positioned the couple and added light from the softbox to camera left—with the softbox held up by my assistant, about two or three feet higher than the couple. With simple portrait lighting, you nearly always want the light to come from at least slightly above your subject(s).

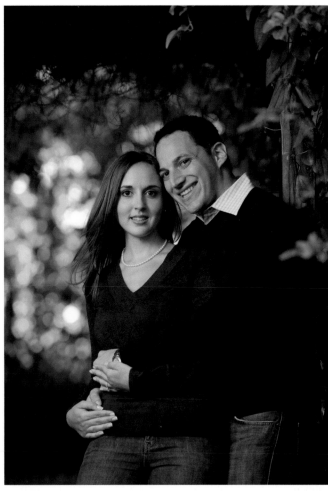

Image 1-5. The sun-soaked leaves created a golden glow behind the couple, who were lit with a flash in a softbox.

For **image 1-6**, I moved so that I was viewing my couple through some leaves. This created a more intimate look—and the leaves produced a kind of border, highlighting her expression. With this kind of image, if I had used flash on my camera, the leaves in front of the camera would have been overexposed. The only way to get light on my subjects, without lighting the foreground, was with off-camera lighting.

I loved the way the backlit, sun-drenched background appeared and I wanted to photograph the couple in front of it (**image 1-7**). Since they were shaded by the trees, they would have been completely underexposed without flash. Or, if I had decided not to use flash but set my camera to expose correctly for them, I would have lost the background entirely. Therefore, the only way to use that background *and* get great light on the subjects was with off-camera flash. (During this photo session, my assistant walked ahead of the couple, holding the softbox up to camera right.)

In short, by adding off-camera flash, you can have perfect lighting nearly anywhere and control your background exposure—and therefore the way you can use the background.

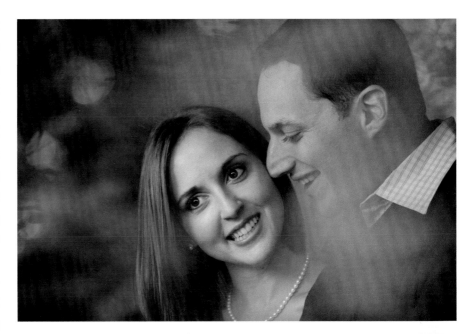

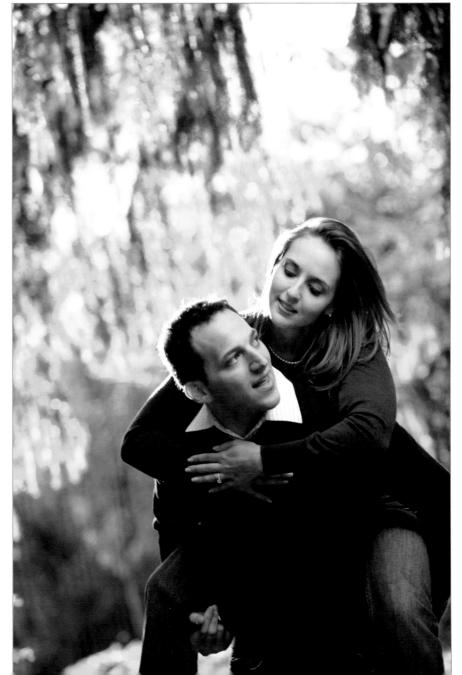

Image 1-6 (top). Off-camera flash was the only solution for lighting the subjects without lighting the leaves in the foreground. ($^1/_{250}$ second, f/4, 400 ISO)

Image 1-7 (right). Adding flash was the only way to balance the subject and background exposure. ($^1/_{250}$ second, f/4, 400 ISO; TTL flash)

Knowing When to Skip the Flash

It is also necessary to recognize when you already have great light—when you don't need to do anything more than find a creative use for it. **Image 1-8** is one of the photos from the session where I didn't use (or need) additional lighting.

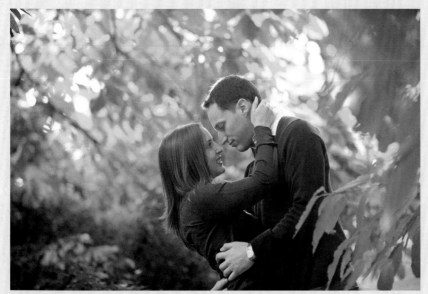

Image 1-8. Sometimes, the existing light is perfect just as it is.

BOUNCE FLASH AS OFF-CAMERA FLASH

As a tangent to the topic of off-camera flash, we should also consider how we can use bounce flash. By bouncing our flash off other surfaces—and even flagging our flash so that no direct flash hits our subject—we can create lighting that appears to be from an off-camera source.

For **image 1-9**, the model was photographed in the early evening, when the ambient light levels were low. As a result, it was easy to get effective light from a flashgun—even when bounced off the side of a building (**image 1-10**). I bounced my flash a bit more forward of where you see the splash of light from the flashgun. The light from the on-camera flash bounced off part of the glass side, pillar, and ceiling. I used a piece of black foam to flag my flash so that I was able to bounce it toward the model without getting *any* direct flash on her. This also gave a directional look to the light from my flash.

The point here is that it is sometimes easier and faster to use on-camera bounce flash than to set up "proper" off-camera lighting—and you can still achieve beautiful, *directional* light. We need to be aware of this possibility, just as we are aware of the times when we already have perfect light and don't have to add any additional light at all.

By bouncing our flash off other surfaces we can create lighting that appears to be from an off-camera source.

Image 1-9 (right). By flagging our on-camera flash, bounce flash never strikes the subject directly and appears to come from off-camera. ($\frac{1}{60}$ second, f/3.2, 800 ISO; TTL flash)

Image 1-10 (bottom). Here you can see us bouncing the flagged flash off a nearby building.

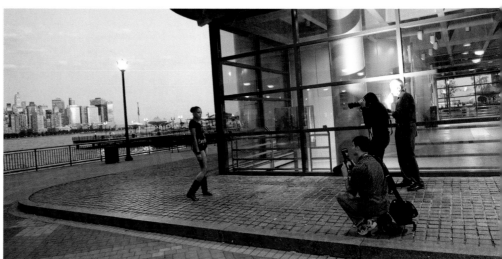

2. Equipment for Off-Camera Flash Photography

While the technology and specific equipment will continue to change and develop over time, the essential techniques that we use in photography will remain valid. Your understanding of the quality and direction of light, and how to balance flash with available light, will remain consistent—regardless of what kind of technology you apply.

Therefore, in this chapter, we will not embark upon a detailed comparison of the various devices and pieces of equipment. (To find out what specific equipment is available on the market, it is best to check with a local or on-line camera store.) We will, however, take a general look at the critical pieces of equipment we will need for successful off-camera flash photography. Basically, we'll be looking at what is needed for a minimalist on-location lighting kit.

FLASHGUN

We do need a flashgun—also called a speedlight or electronic flash. I'd suggest getting at least two. The second will serve as a backup, but it can also be used as a master flash to control a remote slave flash.

Each manufacturer offers a variety of options at different price points. Your initial reaction when stepping into the world of flash photography may be hesi-

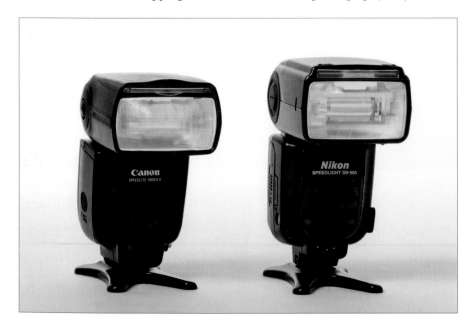

Image 2-1. Flashguns by Canon (left) and Nikon (right).

Other Flashes

Most of the photos shown in this book were taken with a flashgun and a softbox. A few of the images were taken with other types of flash units—but, except for the few examples where a high-powered, on-location lighting setup (such as the Profoto AcuteB 600R lighting kit) was used, all of the images could have been taken with a flashgun. In other words, the vast majority of what is shown in this book could be replicated by any photographer with one or two flashguns.

Image 2-2. The Manfrotto 1051BAC is a smaller light stand.

tance about buying a large and expensive flashgun. This can lead you to err on the side of caution, choosing a flashgun that is cheaper, but also limited in its specifications and ability.

I would strongly recommend that you dismiss any flashguns that don't allow the head to rotate and swivel. The ability to rotate and swivel the flash head opens up a lot of possibilities for us when bouncing our on-camera flash. The ability to rotate 180 degrees to either side is an especially powerful feature, giving you more options when choosing the direction of the light. Anything less would just limit you—and, ultimately, be a waste of your money. You'll be better off investing a bit more money in a more flexible flashgun.

You also need a powerful flashgun. Bouncing flash or using an umbrella/softbox to diffuse the light requires a lot of energy to get enough light on your subject. Therefore, I recommend purchasing the most powerful flashgun you can afford.

I rely heavily on TTL flash technology, so I would also strongly recommend a flashgun that is TTL capable and integrates properly with your camera.

In short, even if this is your first foray into buying a flashgun, I suggest investing in the top model your camera's manufacturer offers. Even if it seems overkill—and a lot of money in comparison to your camera or a lens—the flexibility, power, and ease of integration with your camera system all make the larger flashgun the better choice. A smaller, less capable flashgun could very well just end up frustrating you because of the limited potential it offers. A full-featured flashgun, loaded with mouth-watering specifications, could will make your life easier and your photography more interesting and pleasurable.

SUPPORTING THE FLASHGUN

Light Stands. The size of the light stand you're going to need depends on a few factors: the weight of the light stand; the use of the light stand (on location or indoors); and the maximum load the light stand is going to have to support.

For those photographers who need to travel with their lighting gear, a lightweight stand—such as the Manfrotto Nano—is a good choice. It has a relatively large footprint (the diameter to which the tripod legs fold out), yet folds up to a surprisingly compact size. If you only work indoors with no risk of wind, then a lightweight stand will suffice; if you work outdoors, a heavier stand will be necessary. The taller you need your light stand to extend, the wider the footprint must be. Also, if you're going to use a softbox, you'll need a sturdy stand with a wide footprint.

Monopods/Light Sticks. If you need to be mobile and shoot fast, the most viable option is to have an assistant hold up a monopod with a softbox or undiffused flashgun mounted to it. This simple configuration of a flashgun on a monopod is often called a "light stick."

Some cities and locations have restrictions about the use of tripods and light stands. In this case, an assistant to hold up and carry your off-camera flash becomes a necessity. An assistant with a light stick is often called a "voice activated light stand," since you can have your assistant adjust the position of the light as you shoot—without breaking your rhythm of shooting.

Image 2-3 shows a light stick without a battery pack. Often, photographers will work without a battery pack when shooting like this. Since there is no diffuser to cut down the light, the batteries last much longer than if the flash was bounced or used in a softbox without a battery pack. In its simplest configuration—called a light stick—this is just the flashgun, a Pocket Wizard (to trigger the off-camera flash), a flash hot-shoe stand, and the monopod.

Connecting the Flashgun to the Light Stand/Monopod. If you're only going to use flashguns as direct (undiffused) light sources, then you can get by with just using the plastic foot/hot-shoe stand that was included with your flashgun.

Inexpensive umbrella clamps (**images 2-4** and **2-5**) allow you to mount a flashgun on a light stand, with a hole for the stem of the umbrella to slip into and screwed tight so it can't slip out. The umbrella clamp can also be angled up or down so that you can conveniently position your light source (the umbrella) in relation to your subject.

Most softboxes need to be attached to a speed ring to open up the box and attach it to the light stand (**images 2-6** and **2-7**). Other softboxes come with a

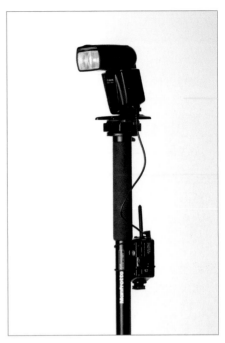

Image 2-3. A light stick without a battery pack.

Images 2-4 and 2-5. The flash is attached to the hot-shoe stand, which is mounted on the umbrella clamp. (No umbrella yet.)

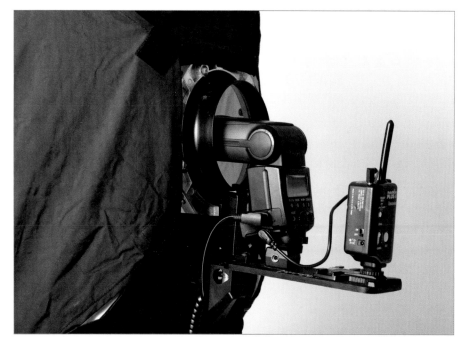

Image 2-6 (left). The more traditional speedring holds the softbox open. Here, it is connected to a slipper, which holds the flashgun and Pocket Wizard.

Image 2-7 (right). A softbox by Lastolite essentially just flips open. There is no need to mount rods into the speedring.

proprietary connector to hold the softbox to the light stand. Check the specifications of the softbox you're looking at.

TRIGGERING THE FLASHGUN

We need some way of triggering our flashguns wirelessly when we shoot on location.

Radio Slaves. With radio slaves, such as the Pocket Wizard Plus II units, you only have manual control over the flash's output. For this setup, the camera has a radio transmitter connected to it via the hot-shoe terminal or the PC

Images 2-8 and **2-9.** Here a Pocket Wizard Plus II unit is mounted to the light stand with a caddy that stops it from swinging free. If your flashgun is an older model, such as the Canon 580 EX seen here, you will need a PC-to-hot-shoe adapter to connect the radio slave to the flash.

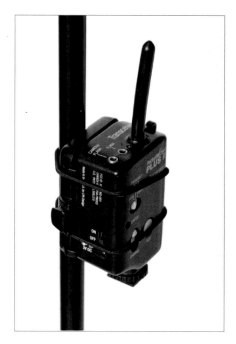
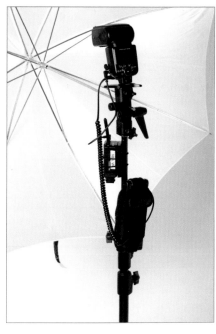

terminal on the side of the camera. Then a radio receiver is attached to each flashgun. (Some units, like the Pocket Wizard Plus II, can automatically act as a receiver *or* a transmitter.)

With this type of connection, there is no "intelligence" between the camera and the flashgun; no data about the camera's aperture or ISO setting can be communicated. The camera's transmitter simply serves to trip the flashgun's receiver the moment you fire the shutter. The flash then fires. Since the flash is set to manual (or sometimes to auto, but not to TTL), you have to meter for your flash's output *beforehand*. (We'll cover this in the next section.)

The Camera's Built-in Wireless System. Most modern cameras offer a way to control (and not just simply fire) the remote flashgun from the camera itself. These allow us to hugely expand our possibilities. With a system like this, you can either have a wireless TTL transmitter (such as the Nikon SU-800 or the Canon ST-E2) control the slave flash, or you can set a flashgun on the camera to act as a master that controls all the other slaved flashes. Many of the photos in this book were done with just that system, using an on-camera flash as the master (but with its own output disabled) to control the slave/remote flash.

There is a limitation with this: the master flash (controller) and slave flash (remote) must be in line-of-sight of each other. Fortunately, there are devices that allow wireless TTL flashes to be controlled without direct line-of-sight. Radio Poppers are the predominant brand at this point, but this will surely change as more manufacturers create devices to work with wireless TTL flash. Radio Poppers have an ingenious way of implementing the communication between the master and slave flashes, using an electronic signal that isn't limited by line-of-sight. This frees us up completely in the placement of our lights and our own movements, allowing greater creative control.

The other two ways of triggering off-camera lighting are optical slaves or cords. These are either unreliable or clumsy, so they aren't recommended at all.

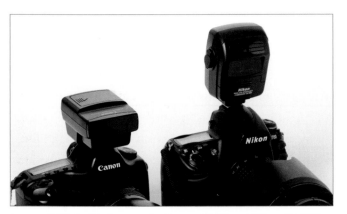

Image 2-10. In this image, the Canon ST-E2 and Nikon SU-800 wireless controllers can be seen. They are more compact than a flashgun set to master mode and mounted on the camera.

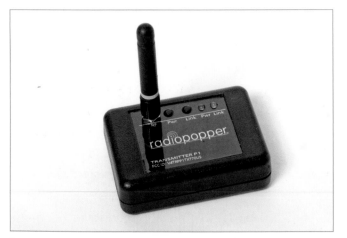

Image 2-11. Radio Poppers can trigger a TTL slaved flash that isn't within line-of-sight of the master.

DIFFUSING THE FLASH

Using direct (undiffused) flash off-camera is common practice and can give dramatic results. However, the smaller light source produces hard, contrasty light. Using a large diffuser or modifier, such as a softbox or umbrella, will create softer shadows. Even a medium-sized softbox is quite a forgiving light source in comparison to the light from a direct flash.

There are examples in this book where direct off-camera flash was used. Sometimes, the simple option of a direct flashgun is easier to move around with on location, or when you need a lot of light from your flash to match the bright sun. My preference is to use a softbox—right up until the point at which I can't get enough light from my flashgun in the softbox.

Umbrellas. An umbrella is the most convenient light modifier to carry around. It folds closed into a relatively

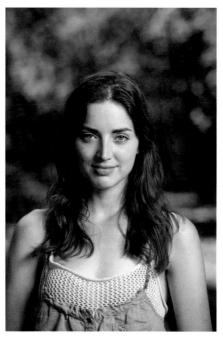

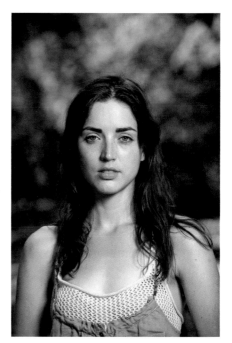

Image 2-12. 24x24-inch softbox with a double baffle.

Image 2-13. 42-inch white shoot-through umbrella.

Image 2-14. 42-inch bounce umbrella.

compact size and is supremely easy to assemble and disassemble. Because umbrellas are quick to set up, I often use them with wedding portraits and formals. For a large group, you may even want to use two umbrellas to get an even spread of light across all the subjects. Fortunately, umbrellas aren't expensive; I suggest getting two 42-inch umbrellas—and I generally use Quantum flashguns and 60-inch umbrellas indoors when I can.

There are two types of umbrellas to consider: reflective (the light bounces out of the umbrella and back onto the subject) and shoot-through (the light shines through the umbrella and onto the subject). Umbrellas that are meant to be used as reflective umbrellas are black on the outside and can come with different materials—white, silver, gold, or a mix between silver and gold—on the interior surface. While the silver umbrella can be very efficient (bright), a white umbrella produces a softer look, since the light is more scattered. Shoot-through umbrellas are white inside and out, allowing the light from the flashgun to be diffused through the umbrella's fabric. You can also choose a white umbrella with a removable black backing; this type of umbrella can be used either as a shoot-through umbrella or as a reflective umbrella.

I primarily use bounce umbrellas with a black backing; this minimizes the risk of getting lens flare when I stand further back than my lights. With a shoot-through umbrella, I have the risk of getting lens flare at this point. In fact, the only time I commonly use shoot-through umbrellas is when I am photographing indoors and need to disperse a lot of light around. For example, I might do this when using the flashes as additional lighting at a wedding venue.

Softboxes. Softboxes give you more control than umbrellas, providing a more focused swath of light. Depending on how your softbox is baffled, it can actually give you more light than an umbrella. With a softbox you also have more control over how the light spills onto the background (although this isn't usually a problem when working outdoors with a simple lighting setup). One factor that *does* make a difference outdoors, though, is that a softbox is easier to handle when you have a bit of wind. An umbrella tends to scoop the wind, leaving you at its mercy.

Side-by-Side Comparison. Images 2-12, 2-13, and 2-14 show an on-location (although non-scientific) comparison of these different modifiers. What would count as the "best result" is open to interpretation. Small differ-

ences did creep in (ambient light changes and the model and myself slightly shifting in position), but I can barely tell the difference between the three light modifiers when used under these typical situation when shooting outside. Ultimately, perhaps, it comes down to personal preference—and to which one is easier to assemble, carry, and set up. For all that, I prefer working with a softbox on location.

POWERING THE FLASHGUN

If you only use your flashgun for fill light, not as the dominant source of light, then you can get away without a battery pack. When you start to use your flashgun a bit more—shooting faster or using more power by working at low ISO settings and smaller apertures—then you're better off using a battery pack of some kind (**image 2-15**).

My first recommendation is a Nikon SD-9A or Canon CP-E4 battery pack. These hold eight AA rechargeable batteries, are very simple to use, and integrate well with your flashgun. Arguably the best rechargeable AA batteries currently on the market are the Sanyo Eneloops. They retain their charge for considerably longer than any other AA battery.

If you need your flash to recycle more quickly (sometimes at the risk of harming your flash), then you can use larger battery packs, such as the Quantum battery packs. I use the Quantum 2x2 and the smaller Quantum SC battery packs, but there are a variety of models on the market. (However, I'd still suggest getting at least the Nikon or Canon battery pack).

The battery pack will help in giving more consistent exposures by recycling your flash more quickly. And, of course, it will allow you to shoot for longer periods without having to change batteries.

The battery pack will help in giving more consistent exposures by recycling your flash more quickly.

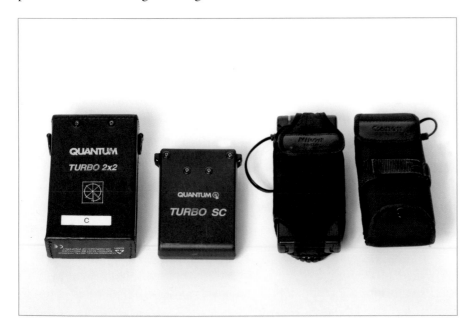

Image 2-15. A selection of battery packs. From left to right: the large Quantum 2x2; the more compact Quantum SC; the Nikon SD-9; and the Canon CP-E4.

LARGER LIGHTING SYSTEMS

There are numerous brands and models of larger battery-powered flash systems that can be used on location. Two that I use are the Quantum and Profoto systems. Currently, the Elinchrom Hydra Rangers are getting a lot of attention, as well—so it would be worth your while to do some investigating before settling on any particular system, should you want to move up from a flashgun-based, off-camera flash system.

Depending on the kind of diffuser or softbox you use, you would need to start in the range of 400–600Ws to match the bright sunlight.

Quantum. The Q-flashes come in two ranges of possible output: the T range, offering a maximum of 150Ws, and the more powerful X range, offering up to 400Ws. The advantage of a system like the Q-flashes over the flashguns is that these workhorses are rugged and can be used for much longer periods without fear of overheating.

Profoto. For a more powerful on-location lighting system that runs off a battery, I have settled on the Profoto AcuteB 600R lighting. The 600Ws output is bright enough that I can match the brightness of the sun even with a double-baffled softbox used at a normal working distance. This kit has the nice feature: a built-in Pocket Wizard module.

METERING THE FLASHGUN

A flash meter (**image 2-16**) is supremely easy to use—and it is the most consistent tool we have for metering our light, whether ambient or flash. In addition to using a flash meter, I also use the camera's histogram to determine exposure when I use manual flash. This is a complex topic, so we'll cover both approaches later in the book (see chapter 5).

Image 2-16. A handheld flash meter.

3. Concepts for Flash Photography

We need to look at a few important concepts before moving on to our examination of implementing off-camera flash and balancing it with ambient light. The concepts we're going to look at in this chapter are: how the camera's shutter works; the maximum flash sync speed; and the use of high-speed flash sync. As we move ahead, we will also be considering manual *vs.* TTL flash, flash exposure compensation, dragging the shutter, metering for ambient light and flash, and using the histogram.

THE CAMERA'S SHUTTER

Think of the shutter of a DSLR as being two curtains that open across a window (the digital sensor). When we trip the shutter, the first curtain opens to reveal the sensor. Then, after a short period, the second curtain closes. The time interval between the first curtain opening and the second curtain closing is the shutter speed. It's usually short—it could be $\frac{1}{60}$ second, or $\frac{1}{2}$ second, or $\frac{1}{500}$ second.

MAXIMUM FLASH SYNC SPEED

Flash, traditionally, is a short pulse of light. With a duration around $\frac{1}{2000}$ second (this can vary depending on the design of the flash unit), it is nearly instan-

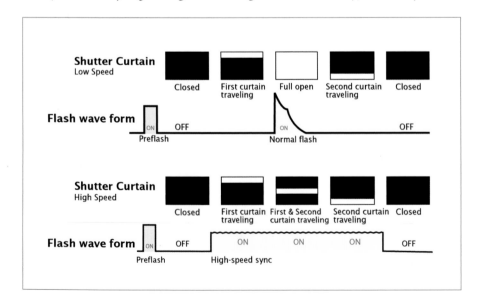

Image 3-1. Flash must be synchronized with the movement of the shutter curtains to create a proper exposure.

When this happens, only part of the frame/sensor will get exposure from the flash.

taneous. For that brief pulse of light to expose evenly across the entire sensor, we need to use a shutter speed slow enough that the entire frame is open at some point during the exposure; the first curtain *must* clear the frame/sensor before the second curtain begins to move, closing it. If the shutter speed is too fast, the first curtain will still be in motion when the second curtain starts to move. Instead of the entire frame/sensor then being open to the blitz of light from the flash, there will be only a narrow window (the opening between the curtains) moving across the frame. When this happens, only part of the frame/sensor will get exposure from the flash.

So, we need to use a shutter speed slow enough that the entire frame/sensor is open to that near-instantaneous burst of light from the flash. On every camera, there will be a certain shutter speed at which the first curtain has just barely cleared and the second curtain is just about to start moving. If you went one click higher than this on the camera's shutter speed dial, one of the shutter curtains would obscure part of the frame during the flash exposure. That specific shutter speed, the fastest shutter speed at which the entire frame is open, is called the *maximum flash sync speed*. It's an important setting on our cameras—and one that we have to keep in mind.

Let's look at two images taken with flash to see what happens when we exceed the maximum flash sync speed. **Image 3-2** was taken at $^1\!/_{250}$ second at f/5.6 and 400 ISO, using manual flash triggered by Pocket Wizards. **Image 3-3**

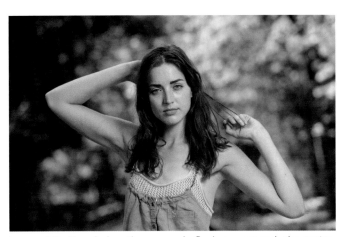

Image 3-2. At or below the camera's flash sync speed, the entire frame is evenly exposed by the flash.

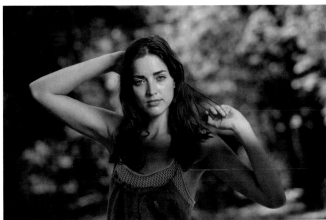

Image 3-3. When the camera's flash sync speed is exceeded, the frame is not evenly exposed by the flash.

was taken at $\frac{1}{400}$ second, which is $\frac{2}{3}$ stop over the maximum flash sync speed of the Nikon D3. You can clearly see that the exposure is uneven, since the shutter curtain blocked the flash's light from hitting the bottom half of the frame. (*Note:* The ambient light is continuous, so it isn't affected by this—except for being recorded as, overall, slightly darker in the second image.)

The maximum flash sync speed varies slightly for different camera makes and models, but is usually in the range of $\frac{1}{200}$ or $\frac{1}{250}$ second. If we go higher than that, we get a dark area in the frame where the light from the flash has been blocked. On-camera flashguns automatically prevent your camera from exceeding the maximum flash sync speed. There's a ceiling there—unless we go to high-speed flash sync mode.

HIGH-SPEED FLASH SYNC

At some point, camera manufacturers devised a truly ingenious way to get around the limitation of having a maximum flash sync speed. Looking at **image 3-1**, we can see how it was implemented. Instead of the energy from the flash being released as that near-instantaneous burst of light, it is now released as a rapid pulsed light; it appears continuous for a brief period.

Since the light from the flash is now continuous, instead of a discrete burst, it will be evenly exposed across the entire sensor when even a narrow window between the two shutter curtains moves across it. As a result, you can use shutter speeds as high as $\frac{1}{4000}$ second—but it comes at a price. The high energy burst of light is now dissipated over a longer period of time. As a result, the flash loses efficiency. If you look at the back of your flashgun's display (with the flash head pointing forward) as you take your shutter speeds up over the maximum flash sync speed, you will see the range of the flash drop considerably.

Let's consider a scenario where we are photographing in bright light. As we change our shutter speed/aperture combination, our flash's range changes, too. For example, at f/16 our flash's range is usually in the order of a few feet. Open the aperture to f/4 and the range dramatically increases. So it would appear the wider our aperture the more range we get from our flash—the greater distance the flash output will reach.

But working in available light, our aperture choice is also linked to our shutter speed choice. So while we change our apertures by going wider and wider, we have to increase our shutter speed to maintain the ambient exposure. Unfortunately, we hit a ceiling at the maximum flash sync speed. In the normal flash mode, we can't go over the maximum flash sync speed—but if we change to high-speed sync, our range drops as we increase our shutter speed.

This reveals that we get the most power from our flashgun at the maximum flash sync speed, since this is the widest aperture we can get while remaining in the normal mode of flash dissipation.

It would appear the wider our aperture the more range we get from our flash.

This is the kind of thing where we really need to sit and play with our cameras in our hands and see how the camera controls affect the flash display on the back of the flash. We need to look at how the range changes as we change apertures, and change the shutter speeds accordingly. (For more information on this, visit http://neilvn.com/tangents/2008/12/13/max-it-out/.)

COMPARING HIGH-SPEED FLASH SYNC WITH NORMAL FLASH SYNC

The best way to see what happens above the normal maximum flash sync speed, as we enter the realm of high-speed flash sync, is to look at comparative photographs. These will give us a clear idea of what actually happens before, at, and beyond the maximum flash sync speed.

To do this, I set up very simple portrait lighting using a single flashgun with a large umbrella, a white paper-roll backdrop, and our model, Rachel. There was a large (60-inch) umbrella to my left, and a small reflector to the right to add a little bit of fill. I stayed close to the umbrella, keeping it as close to the lens axis as possible so that the light is as even as we could manage with a single-flash setup. For this example, it was important to use only one speedlight so that we could accurately observe its behavior.

For all the images in this next explanation, the flash was set to full output in manual mode. This way we aren't bringing in the uncertainties of TTL flash. (Since TTL flash is an automatic metering mode, it would produce variations in output with any change in our composition.) Manual flash is consistent and predictable. I worked at full output here so that we could more clearly see some of the effect of going to high-speed flash sync.

Initially, I triggered the flashgun with radio transmitters—PocketWizard Plus II units, which don't allow high-speed flash sync. For the final sequences, where we go to high-speed sync (HSS), I used an on-camera flash as a master, to fire the slaved flashgun mounted with the umbrella. The master's output was disabled, so we're just dealing with the single slave flashgun's effect.

In the spirit of keeping much of the info in this book system-agnostic, we'll look at how both the Nikon D3 and the Canon 5D work in this scenario.

To briefly recap, with high-speed flash sync—a truly amazing bit of engineering—the flash's output is released as a rapid series of light pulses. The flash is now effectively a continuous light source over a very short duration. As noted, this change from a high-energy, near-instantaneous burst of light (normal flash) to the short period of continuous light (high-speed flash sync), does imply a loss of effective power. This makes sense, since a lot of the light from our flash will just hit the shutter curtains, not the actual sensor. In other words, much of the output from the flash in high-speed flash sync mode will be lost.

Normal Flash Sync. First, let's look at how the flash output appeared using old-school radio slaves, which don't allow us to go to high-speed flash sync.

I set up very simple portrait lighting using a single flashgun with a large umbrella . . .

This is how studio-type shoots are usually set up—various flashes and light modifiers set up, then the flashes are fired by radio slaves using normal flash sync. (In other words, no high-speed flash sync.)

The first sequence (**images 3-4** to **3-12**) was created using the Nikon D3. The second sequence (**images 3-13** to **3-21**) was shot with the Canon 5D. I wanted to show that the behavior of normal flash sync and maximum flash sync speed is universal for all focal plane shutters found on DSLRs.

The Nikon D3 (like most of the bigger Nikon DSLRs) has a maximum flash sync speed of $^1/_{250}$ second. Below

Image 3-4.
($^1/_{125}$ second, f/11)

Image 3-5.
($^1/_{200}$ second, f/11)

Image 3-6.
($^1/_{250}$ second, f/11)

Image 3-7.
($^1/_{320}$ second, f/11)

Image 3-8.
($^1/_{400}$ second, f/11)

Image 3-9.
($^1/_{500}$ second, f/11)

Image 3-10.
($^1/_{640}$ second, f/11)

Image 3-11.
($^1/_{800}$ second, f/11)

Image 3-12.
($^1/_{1000}$ second, f/11)

that, and if there is not much ambient light, the choice of shutter speed has *no* effect on the flash. We just need the entire sensor/frame to be open to the blitz of flash. This can be at ⅛ or ¹⁄₆₀ or ¹⁄₁₂₅ second—any shutter speed that is at or slower than the maximum flash sync speed. However, we can see here that, at ¹⁄₂₅₀ second, we start

to see the edge of the one shutter curtain. This is due to propagation delay. (More about this in a short while.)

Images 3-13 to **3-21** show the same image sequence for the Canon 5D. The 5D has a maximum flash sync speed of ¹⁄₂₀₀ second, and we see the same effect with the higher shutter speeds obscuring the flash exposure.

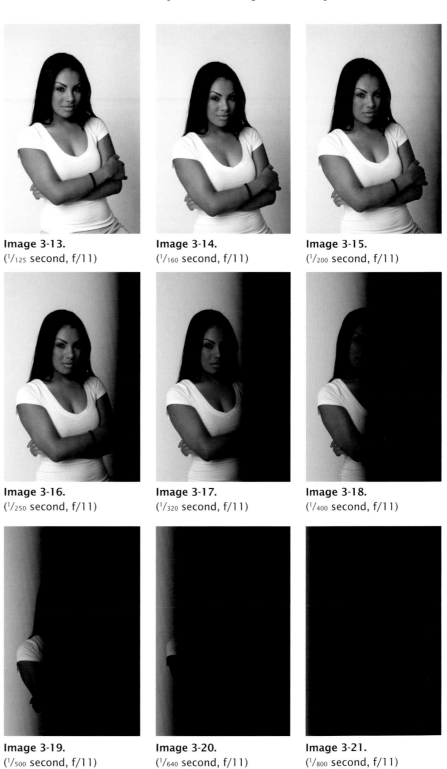

Image 3-13.
(¹⁄₁₂₅ second, f/11)

Image 3-14.
(¹⁄₁₆₀ second, f/11)

Image 3-15.
(¹⁄₂₀₀ second, f/11)

Image 3-16.
(¹⁄₂₅₀ second, f/11)

Image 3-17.
(¹⁄₃₂₀ second, f/11)

Image 3-18.
(¹⁄₄₀₀ second, f/11)

Image 3-19.
(¹⁄₅₀₀ second, f/11)

Image 3-20.
(¹⁄₆₄₀ second, f/11)

Image 3-21.
(¹⁄₈₀₀ second, f/11)

High-Speed Flash Sync. Now, let's see what happens when we go past the maximum flash sync speed, with high-speed flash sync enabled. **Images 3-22** to **3-30** show what the Nikons do—and, actually, this is what pretty much *every* camera with high-speed sync capability does.

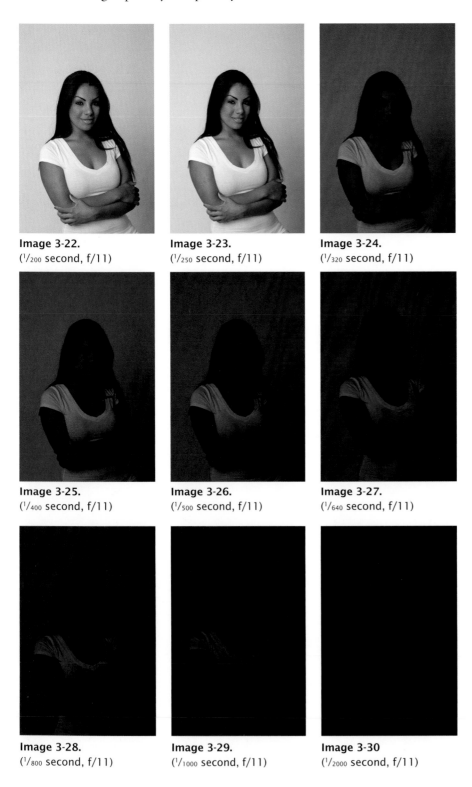

Image 3-22.
($^{1}/_{200}$ second, f/11)

Image 3-23.
($^{1}/_{250}$ second, f/11)

Image 3-24.
($^{1}/_{320}$ second, f/11)

Image 3-25.
($^{1}/_{400}$ second, f/11)

Image 3-26.
($^{1}/_{500}$ second, f/11)

Image 3-27.
($^{1}/_{640}$ second, f/11)

Image 3-28.
($^{1}/_{800}$ second, f/11)

Image 3-29.
($^{1}/_{1000}$ second, f/11)

Image 3-30
($^{1}/_{2000}$ second, f/11)

Images 3-31 to **3-39** show what the Canon 5D does. It's very similar to the Nikon D3, with a slight quirk at the point where we get to the maximum flash sync speed. On the Canon 5D and 5D Mark II bodies, the high-speed flash sync kicks in *at* the maximum flash sync speed ($^1/_{200}$ second) when the little "H" button is selected on the back of the Canon speedlight. As you can see, the high-speed sync flash output (**image 3-33**) is quite different from that seen with normal flash (**image 3-32**).

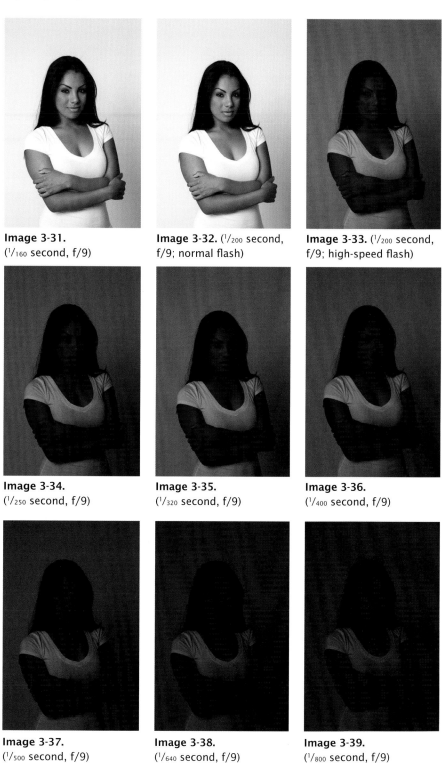

Image 3-31.
($^1/_{160}$ second, f/9)

Image 3-32. ($^1/_{200}$ second, f/9; normal flash)

Image 3-33. ($^1/_{200}$ second, f/9; high-speed flash)

Image 3-34.
($^1/_{250}$ second, f/9)

Image 3-35.
($^1/_{320}$ second, f/9)

Image 3-36.
($^1/_{400}$ second, f/9)

Image 3-37.
($^1/_{500}$ second, f/9)

Image 3-38.
($^1/_{640}$ second, f/9)

Image 3-39.
($^1/_{800}$ second, f/9)

So, let's look at the implication of those image sequences. The moment we go over the maximum flash sync speed, the output from our flash drops considerably. It makes sense: if we are in normal flash mode, then the flash is an instantaneous burst of light. For the flash exposure to be consistent from edge to edge, we just need our entire frame/sensor to be open. The moment we go into high-speed sync mode, the flash output is essentially continuous light—and continuous light is affected by our shutter speed choice. Think of ambient light. If we change our shutter speed, we change our exposure. This is exactly what happens with flash in high-speed flash sync mode.

The Linear Response of High-Speed Flash Sync. As mentioned, since high-speed flash acts like continuous light, it should have a similar linear response to changes in shutter speed. So let's see what happens when we change the aperture in relation to the change in shutter speed (**images 3-40** to **3-45**). We're looking at Nikon images here, but what you see here will also hold true for Canon's flash systems, as well as other camera systems.

The linear response can clearly be seen—$\frac{1}{500}$ second at f/4, $\frac{1}{1000}$ second at f/2.8, $\frac{1}{2000}$ second at f/2. This also makes it obvious why we need to be at, or just below, the maximum flash sync speed when working in bright light and trying to overpower the sun with flash.

For the examples with normal flash, we had $\frac{1}{250}$ second at f/11. For ambient light only, this would translate to $\frac{1}{2000}$ second at f/4 (as an example). Yet, when going to high-speed flash sync we have an equivalent of $\frac{1}{2000}$ second at f/2. Basically, we lose about two stops. This implies several things:

1. When we work in bright ambient light, then we have a sweet spot at (or just below) the maximum flash sync speed where we get the most efficiency from our flash. This is because the higher shutter speed implies a wider aperture, and this wider aperture allows our flash to reach further, or work less hard for the same exposure.

Image 3-40.
($\frac{1}{500}$ second, f/11)

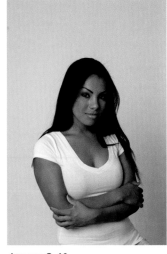

Image 3-41.
($\frac{1}{500}$ second, f/4)

Image 3-42.
($\frac{1}{1000}$ second, f/11)

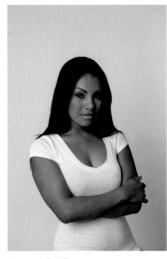

Image 3-43
($\frac{1}{1000}$ second, f/2.8)

Image 3-44.
($\frac{1}{2000}$ second, f/11)

Image 3-45.
($\frac{1}{2000}$ second, f/2)

2. If we want correct flash exposure with high-speed flash, we need to move our flash much closer to our subject to use it as the dominant source of light—or we need to be aware that our flash will be merely fill light, since the output is dramatically reduced.

3. If we want to control our depth of field, we are better off using neutral density filters than going to high-speed sync mode. (This is covered in chapter 8 on overpowering the sun with flash.)

4. You can't overpower the sun by going to high-speed flash sync. If anything, you should *not* use high-speed when you are dealing with bright light. You need to do something entirely different to overpower the sun with flash. This idea that you go to a much higher shutter speed to control the available light when you use flash is one of the biggest fallacies I've come across on the various photography forums. *It simply does not work that way.*

5. Because of the loss of effective power with high-speed flash sync, you need to double up—or quadruple up—on flashguns to compensate in bright light. Alternately, you can move the flashgun much closer, and use direct off-camera flash.

PROPAGATION DELAY

As you saw in the sequence of images for the Nikon D3 and the Canon 5D, even though you might be working at maximum flash sync speed, you might still get the edge of a shutter curtain in your image. This is due to something called "propagation delay."

For **image 3-46**, I used Pocket Wizard Plus II radio transceivers to trip the flash. As mentioned earlier, they are simple devices that just trigger the speedlights. There is no intelligence there between the camera and speedlights.

This is where slight synchronization errors can creep in. When working at the maximum flash sync speed, we're on the very edge of the camera's capabilities. When we trip the shutter, the camera has to fire the transmitter mounted on it. This then trips the receiver connected to the flashes, which in turn fires those flashes. This whole chain of events takes place within a small, finite time—and that is where any slight synchronization error will show up—as it does here with the edge of the shutter curtain showing.

This is a common occurrence, not one that is inherent to the two cameras I used here. Most studio shooters will have experienced this problem and know to use a shutter speed lower than maximum flash sync speed when shooting in the studio. A shutter speed like $^1\!/_{125}$, $^1\!/_{100}$, or $^1\!/_{60}$ second is fine when working in the studio. Where ambient light levels are low, the shutter speed has no effect then on the flash exposure, so any shutter speed lower than maximum flash sync speed is fine.

Image 3-46. When shooting at the maximum flash sync speed, you might get the edge of a shutter curtain in your image.

On-location, however, I do use maximum flash sync speed—even if there is the chance of propagation delay. With on-location photography, we are much less likely to see the effect of flash exposure at the edge of the frame. For example, with portrait photography on location, our subjects are usually more centrally placed. Hence, propagation delay doesn't really affect the on-location shooter. I would just shoot at the maximum flash sync speed anyway to give me the most efficiency from my flash.

WHEN TO USE HIGH-SPEED FLASH SYNC

Given that the effective output from our flashguns is reduced by at least half when we exceed the maximum flash sync speed, why would we want to use high-speed flash sync?

We would go to high-speed flash sync when we need a high shutter speed (higher than the maximum flash sync speed) to freeze motion or when we need a wide aperture to isolate our subject from the background. If you only need the merest hint of fill flash, then high-speed flash sync works well. Being aware of the loss of power, you can also move your flashgun closer to your subject or use two or more flashguns to compensate for the loss in power.

In **image 3-47**, I wanted to freeze the model, Aleona, as she leapt up in the air—and not risk getting subject blur due to movement. Therefore, I selected a high shutter speed, forcing the flash to go into high-speed flash sync mode. This gave me even flash exposure across the entire frame.

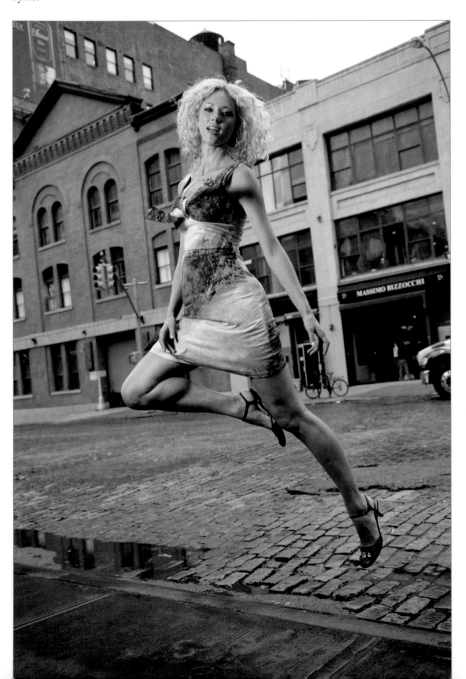

Image 3-47. Direct, off-camera flash in high-speed flash sync mode froze the model in midair. ($1/2000$ second, f/3.2, 400 ISO)

4. Manual Flash *vs.* TTL Flash

Manual flash and TTL flash are two entirely different beasts. We'll have to consider them separately. (*Note:* With modern DSLRs, flashguns in the automatic mode operate in a similar way to TTL, so I'm not going to discuss that mode specifically.)

MANUAL FLASH

When set to manual, the flash releases a certain amount of power every time. For example, if we set our flash to ¼ of full power, it will give exactly that much power every time it is tripped: ¼ of its full capacity. Obviously, ¼ power is going to differ vastly between various makes and models of flashguns and strobes and lighting kits. But ¼ power for any specific flash is always ¼ of whatever that particular flash is capable of producing—and it will remain consistently that. It doesn't change.

Manual flash exposure is controlled by four things:

1. Our choice of aperture
2. Our choice of ISO
3. The distance from the light source to our subject
4. The power setting on our flash (and including how we decrease the effective power with light modifiers like softboxes and umbrellas)

When set to manual, the flash releases a certain amount of power every time.

With a bit of thought, all these factors should be obvious in how they affect our manual flash exposure. If we change our aperture, we control how much light reaches our sensor through the lens. The same goes for ISO settings as we increase or decrease our sensor's response to light. The distance from the light source to our subject is also another obvious factor; if we move our softbox closer to our subject, we will have more light on our subject. If we have determined the correct exposure for our manual flash, then changing any one of these settings will necessitate changing one of the other settings to compensate.

This is the beauty of manual flash: consistency. Once we've set it up and determined the correct exposure, then nothing changes.

Now, let's consider ambient light. Ambient exposure is controlled by three things:

1. Shutter speed
2. Aperture
3. ISO

If we compare these to the list for manual flash, we'll see that shutter speed is missing from the list of things that control manual flash exposure. *While we remain at or below the maximum flash sync speed, the shutter speed has no influence on flash exposure*; we just need that window to be completely open over our sensor/frame. This leaves shutter speed as our *only independent control* when using manual flash. (*Note:* The moment we go over maximum flash sync speed and use high-speed flash sync, then our shutter speed *does* affect the flash's output—but this is because the flash's light now acts as continuous light.)

If we have the correct manual flash exposure, then changing our *aperture* for the ambient light means we are changing our flash exposure as well. To maintain the exposure, we have to change something else to compensate—such as the power setting on the flash. Everything is locked in place with manual flash. This all means that changing the *shutter speed*, rather than the aperture, is the easiest way to affect our ambient exposure without changing our manual flash exposure. Shutter speed is usually the first thing we will change if we want our background darker or brighter (without going over to high-speed flash sync mode).

Shutter speed is usually the first thing we will change if we want our background darker or brighter . . .

TTL FLASH

That is manual flash, then: aperture, ISO, distance, power. With TTL flash, none of those settings have a direct effect on the flash exposure. Instead, the camera and flash calculate, through a pre-flash emitted before the main output, how much light the flash should emit for a correct exposure. (See **image 4-1** for the position of the preflash in this chain of events.)

Considering those four controls for manual flash (aperture, ISO, distance, and power)—with TTL flash the camera now controls how much power the flash should put out, so that the flash output will follow the aperture and ISO choice. The distance is also taken into account by measuring how much of the pre-flash is returned when reflected off the subject and scene. As you can tell, TTL flash technology is an automatic metering mode. Therefore, the amount of flash isn't fixed and can't be metered beforehand. The pre-flash also tends to trigger the metering of most flash meters prematurely, so the value read by most flash meters isn't correct when TTL flash is used. (*Note:* The preflash also explains why optical slaves aren't a good idea when you're using TTL flash.)

Image 4-1. High-speed flash sync.

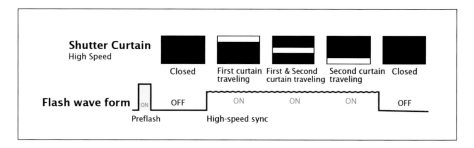

TTL FLASH IN PRACTICE

The difference between manual flash and TTL flash is so pronounced that we need to look again at this statement: *with TTL flash, the flash output will follow your choice of aperture and ISO.* Your camera and flash work together to calculate TTL flash exposure. The camera then adjusts the power the flash emits, giving you what it deems to be a correct exposure—regardless of your choice of aperture, or your choice of ISO, or the distance of your flash to the subject. Of course, these things have to be within reason. You have to work within the capabilities of your flash.

Let's see how this works in practice. With our model, Aleona, positioned in the shade under an awning (**images 4-2** through **4-5**; next page), we have two areas to expose for: first, we have the ambient exposure to consider for the outside background; second, we have the flash exposure to consider for our subject, Aleona.

We control the ambient light exposure on the background using the shutter speed, aperture, and ISO. That's simple enough. The flash exposure settings will determine the light on our subject . . . so how we approach this will depend on whether we are using manual flash or TTL flash.

If I had used manual flash here, I would have had to meter my manual flash for the specific choice of aperture, ISO, distance, and power setting of my flash—then juggle those four things to give me the correct exposure as metered with a flash meter (or perhaps checked via the camera's histogram). Instead, I used wireless TTL flash, with the slaved flash in a softbox controlled by the on-camera master flash.

I purposely set out to use TTL flash here to illustrate a point: with TTL flash, the choice of aperture effectively becomes transparent at our flash exposure. With TTL flash, our choice of aperture (within reason) has no effect on flash exposure. This is also true for our choice of ISO. Compare **images 4-2** and **4-4**. Here, I changed the aperture from f/2.8 to f/5.6—and the flash exposure (the light on the subject) looks virtually the same in each frame. The background exposure changed, though. (Remember, aperture *does* affect available light.)

With TTL flash, I could change my aperture as I needed (within reason) and the camera gave me a correct exposure—without me having to change the

With TTL flash, the flash output will follow your choice of aperture and ISO.

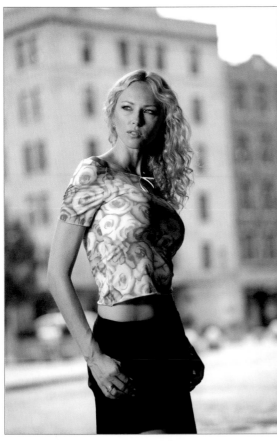

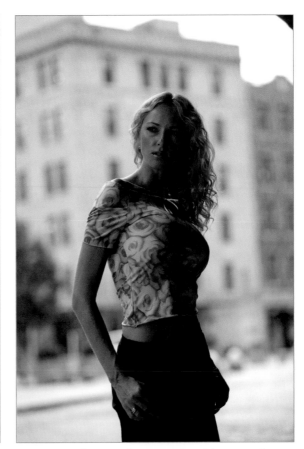

Image 4-2. Aleona under an awning. ($^1/_{250}$ second, f/2.8, 100 ISO; TTL flash at +0.7 EV)

Image 4-3. Aleona under an awning. ($^1/_{250}$ second, f/2.8, 100 ISO; ambient light only)

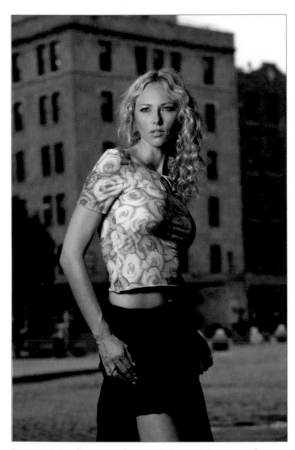

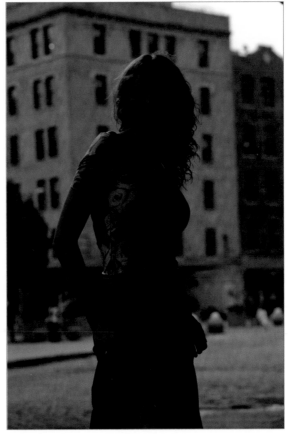

Image 4-4. Aleona under an awning. ($^1/_{250}$ second, f/5.6, 100 ISO; TTL flash at +0.3 EV)

Image 4-5. Aleona under an awning. ($^1/_{250}$ second, f/5.6, 100 ISO; ambient light only)

ISO or the distance of the flash to the subject as I would have had to with manual flash. I did not have to change anything; my camera and flash did—here, via TTL flash. (*Note:* I did have my flash exposure compensation set to +0.7 EV for every image in this sequence because the strong backlighting influenced the TTL flash metering.)

If this had been manual flash, I would have had to change my ISO setting, increase the power on my flash, or bring the flash closer to my subject to compensate for the change in aperture. This could have interrupted the rhythm of shooting. With TTL flash, though, I could fluidly change my settings and concentrate on photographing the model.

Sure, the flash had to work much harder at f/5.6 than it did at f/2.8—in fact, it had to dump four times the amount of light—but my exposure remained the same. This is the reason why, even with TTL flash, we'd rather change the shutter speed first to affect our ambient exposure—even if we don't *have to*, like we would normally *have to* with manual flash.

Two of the general rules of manual flash photography are: one, that shutter speed controls the ambient exposure; and two, that aperture controls the flash exposure. While this is true in a *limited* way for manual flash, it isn't true for TTL flash. As we could clearly see in the examples with Aleona, the *ambient* exposure was controlled by the aperture, but the *flash* exposure was *not* controlled by the aperture.

FLASH EXPOSURE COMPENSATION

Since a change in aperture doesn't affect our TTL exposure, we need to adjust our TTL flash exposure with flash exposure compensation. This is the *only* control for TTL flash.

With fill flash (using TTL or automatic flash), you will most often dial down your flash exposure compensation to give only a fraction of the light. In this case, your flash exposure compensation will be around −1 to −3 EV. Of course, this depends on the tonality of your subject, as well.

When your flash is your main source of light, your flash exposure compensation could range anywhere from around −2 to +2 EV but will normally hover around 0 to +0.7 EV. Again, this will depend on the camera, the camera system, and the tonality of your subject and scene.

There are a number of factors that will affect how your camera and flash will meter the TTL flash and, therefore, how much flash exposure compensation needs to be dialed in. These include:

- The reflectivity of your subject
- How much of your frame is filled by the subject
- How far the subject is from the background

With TTL flash, I could change my aperture as I needed (within reason) . . .

- Whether the subject is off-center or centered within the frame
- The individual camera's exposure algorithms
- The available light (this ties in with how the camera's metering algorithms work)
- Any backlighting (strong backlighting nearly always requires more flash exposure compensation)

You will have to juggle all these factors when figuring out how much flash exposure compensation to use. This seemingly tough task gets easier with experience. Here's a hint: when your flash acts only as the fill light, the flash exposure compensation can vary a lot without affecting the quality of the final image that much.

DRAGGING THE SHUTTER

When using flash on a subject in front of a background lit by available light, a combination of settings is usually chosen to retain the mood of the place—or at least to allow the available light to contribute to the image.

As we delve into this topic, let's review some key points from earlier in this book. For ambient exposure, we have three controls for our exposure: shutter speed, aperture, and ISO. With flash, we have two completely different factors to consider: whether to use manual flash or TTL flash. We will have to consider these separately because, as mentioned in the previous section, their behavior and exposure controls are fundamentally different.

Manual Flash. For manual flash, we have four controls: aperture, ISO, distance, and power. The distance control refers to the distance from your light source to the subject; the closer you move your manual flash (perhaps in a softbox) to your subject, the brighter the light on the subject will be. Naturally, this will affect your exposure. Similarly, it should already make sense that if we increase or decrease the power setting on our manual flash, this too will affect the exposure.

Now, comparing the controls between what affects ambient exposure and what affects manual flash exposure, we can see that there are two common controls: the aperture and ISO. This means that the shutter speed becomes the only independent control for the available light exposure. Therefore, when we want to control the balance of manual flash and ambient light, it makes the most sense to start by adjusting the shutter speed—since adjusting either the aperture or ISO will affect both the ambient light *and* the manual flash exposure.

Within a certain range, shutter speed has no effect on flash exposure. This is a crucial concept that will allow us to better mix flash with available light. The reason why shutter speed doesn't affect flash exposure is that flash is nearly instantaneous and ambient light is continuous. You just need the entire picture area (frame/digital sensor) to be open to be lit by the burst of flash from your flashgun. During any time that the shutter remains open beyond the flash burst, only the ambient light will register. This technique is called "dragging the shutter."

In our next image sequence (**images 4-6** through **4-10**), the model was posed against the Manhattan skyline and lit by manual flash. The background light is, obviously, only the ambient/available light; the flash had no effect on the background exposure.

The only thing that changed between these images was the shutter speed, which I changed by ⅔ stop each time. With each change in shutter speed, the background changed in brightness. This is because the shutter speed controls how much ambient light is recorded but not the flash exposure. As you will notice, the exposure for our model, lit only by manual flash, remained consistent throughout the series. (*Note:* At some point, as we continue to lower our shutter speed, we would reach a stage at which the ambient light is correct for our subject—then we can't keep adding flash exposure.)

How you choose to record the background is a matter of taste at this point; there is a fair amount of leeway as to what could be considered to be a "correct" exposure. To do this, use your camera's light meter as a guideline to determine how much ambient light you would like to register. Somewhere around 1.5 to 2 stops underexposure will usually give you sufficient detail in the background. Then, add the flash as a main light source to expose cor-

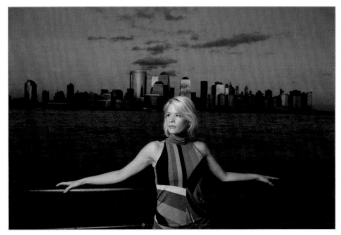

Image 4-6. ($^1/_{250}$ second, f/5.6, 400 ISO.)

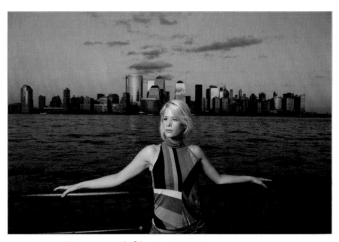

Image 4-7. ($^1/_{160}$ second, f/5.6, 400 ISO.)

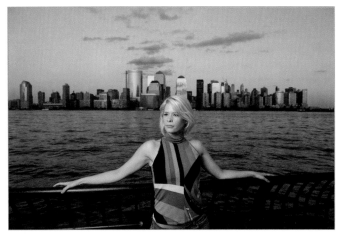

Image 4-8. ($^1/_{100}$ second, f/5.6, 400 ISO.)

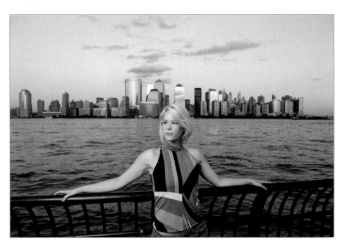

Image 4-9. ($^1/_{60}$ second, f/5.6, 400 ISO.)

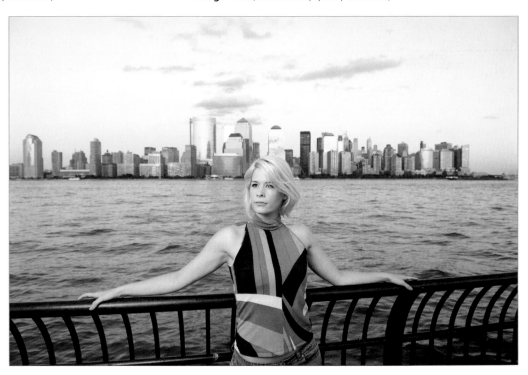

Image 4-10. ($^1/_{40}$ second,
f/5.6, 400 ISO.)

rectly for your subject. This is, of course, assuming your subject is darker than the background.

TTL Flash. TTL flash is altogether different from manual flash. With manual flash you have four controls for flash exposure (aperture, ISO, distance, and power). With TTL flash, however, none of those influence the flash exposure. Your camera and flash will follow the chosen aperture, ISO combination, and change in distance, giving you what is deemed to be a "correct" exposure by adjusting the output (power) from your flashgun.

Given that the camera and flash will ensure a consistent exposure on our subject, this implies that we can use aperture, ISO, and shutter speed—all three controls—to control the available light in the rest of the image. (Of course, common sense needs to be applied here; you can only squeeze so much light out of your flashgun.) With manual flash, if you decided to change any of your settings, you'd have to change one or more of the other settings accordingly to maintain the correct exposure for the manual flash. With TTL flash, if you decide to change your aperture to control your available light, then (in theory at least) your TTL flash exposure will remain the same, since your camera and flash will still give you what they deem to be the correct exposure. The same goes for ISO and distance. These settings, in effect, become transparent to TTL flash exposure. (See the sequence of photos with our model Aleona—**images 4-2** though **4-5**.)

With manual flash, shutter speed is the only independent control for your available light, and you "drag the shutter" to allow more available light in. With TTL flash, you can change your ISO and aperture as well, allowing more available light in, then adjust your flash exposure compensation as needed to control your TTL flash exposure.

Techniques for balancing flash and ambient lighting will be covered in greater detail in chapter 6.

These settings, in effect, become transparent to TTL flash exposure.

5. Metering for Flash and Ambient Light

METERING FOR THE AMBIENT LIGHT

There are a number of ways we can meter for the ambient light with varying degrees of accuracy and convenience. You might use one of these methods or an iterative process involving a few of them.

- Handheld light meter
- Camera's meter
- Camera's histogram
- Blinking highlights display
- Camera's LCD image
- Sunny 16 rule

METERING FOR MANUAL FLASH

Similarly, we can meter for manual flash or check our exposure for manual flash in a few ways. (The one thing we can't do yet is meter for manual flash with our cameras.)

- Handheld light meter
- Camera's histogram
- Blinking highlights display
- Camera's LCD image

METERING FOR TTL FLASH

With a few exceptions we can't use a flash meter for TTL flash.

With a few exceptions we can't use a flash meter for TTL flash. Instead, we have to rely on the technology to give us results that are at least close to a correct exposure. If we disagree with what the camera and flash decide is correct, we have to adjust it with our flash exposure compensation. Essentially, we can check *afterward* to see if our TTL flash exposure was good, but we can't determine correct exposure beforehand (as we can with manual flash).

TTL flash has the benefit of allowing us to work more quickly by letting the camera and flash decide what it correct. However, it can also be a problem. Since TTL flash metering is an automatic metering mode, the camera will be influenced by the tonality of the subject and scene (*i.e.,* how much of it is dark

or bright) and by backlighting. Neither of these are a problem when we use manual flash.

USING A HANDHELD LIGHT METER/FLASH METER

A light meter can measure ambient light and manual flash. (Again, not TTL flash). Nowadays, light meters and flash meters are mostly regarded as the same thing. I would suggest not bothering with a light meter that doesn't meter flash. In this book, I will mostly refer to it just as a light meter, implying that it is in fact a flash meter, too.

A light meter is simplicity itself to use. With some models, you can meter the reflected light by pointing it at an area and measuring the amount of light reflected off your subject or background. The light meter's strength, however, lies in using it as an *incident light meter*, measuring the amount of light falling onto the subject. Measuring the incident light eliminates any problem like the camera's meter being affected by the tonality of the subject and scene. Because the incident light meter measures the light falling onto the subject, it won't matter whether your subject is wearing white or black. To use an incident light meter, hold it close to your subject and point it toward your light source. Then press a button and read the light. It is usually shows a suggested aperture that you should set your camera to.

Some flash meters have built-in radio triggers that will fire the flash. Others require you to press a button to activate the meter, which then waits until it measures a bright pulse of light. So let's say you have your flash and softbox set up on a light stand near your subject. You have set your flash up to give off a certain amount of light—let's say it's at ½ power. Simply fire the flash, and the light meter will tell you what aperture should be chosen for the ISO you dialed in. It's beautifully simple and accurate.

Some flash meters have built-in radio triggers that will fire the flash.

YOUR CAMERA'S BUILT-IN METER

Your camera has a built-in light meter that measures, through its lens, the amount of light reflected from your subject and scene. The camera's meter is very accurate, but it can be affected by a scene that has very bright or very dark areas.

This is because your camera's meter evaluates everything it sees, then gives you a meter reading designed to provide an overall exposure level equivalent to

Image 5-1. Your camera evaluates the range of tones before it and provides a reading designed to produce a middle gray tonality (5 on this scale).

medium gray. The meters on modern DSLRs are amazingly good; they evaluate various parts of the scene, then use algorithms to decide which areas should be given prominence. This way, when the camera biases the meter reading. (This is called "evaluative" or "matrix" metering.) However, the meter is still trying to average the tones to gray. We need to understand this point if we are going to effectively use our cameras' built-in meters.

If the scene in front of us contains roughly equal parts of dark and bright areas, then our camera will quite likely give us a correct meter reading—within $\frac{1}{3}$ stop or so.

Metering White Tones for Ambient Light. Where the camera's built-in meter can be used quite effectively is in metering for a specific tone. A tonal value that we can easily meter for, and one that will also be quite accurately pegged on our histogram, is any area of white on our subject—like their clothing. For example, in **images 5-2** and **5-3**, Anelisa is wearing a white top. By pointing my camera at her shirt and making sure it fills the *entire* frame, I can place this white tone with a fair amount of accuracy on my camera's meter.

Image 5-2 (above). Filling the frame with the white shirt to meter.

Image 5-3 (right). Placing the white tone results in an accurate exposure.

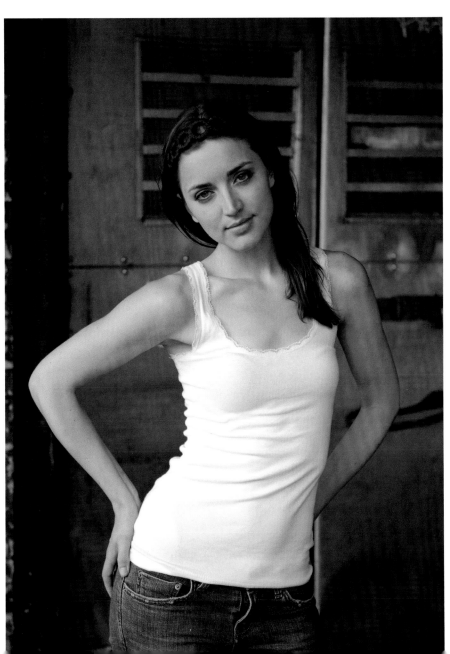

When you use an even white surface as the tonal value to base your exposure on, be aware that different cameras' meters and histograms respond differently. For the Canon 5D, I know I need to open up (increase my exposure) by 1.7 stops—five clicks on the camera controls. For the Nikon D3, I open up 1 stop. This is three clicks on the camera controls. (*Note:* Cameras are, by default, set for $\frac{1}{3}$ stop increments for shutter speed, aperture, and ISO values. If by any chance you have set your camera for $\frac{1}{2}$ stop increments, switch it back to $\frac{1}{3}$ stop increments. The entire world works in $\frac{1}{3}$ stop increments!)

The camera should give you a histogram display very similar to **image 5-4**. You can see that the brightest value on the histogram is right at the edge—exactly where we want our brightest tone of our subject to be, since she is wearing white. This, then, is an easy method for using the camera's meter and histogram to determine accurate ambient exposure—if your subject has white (or very light) clothing. This method is not as directly useful if your subject has no white or equally bright tonal values.

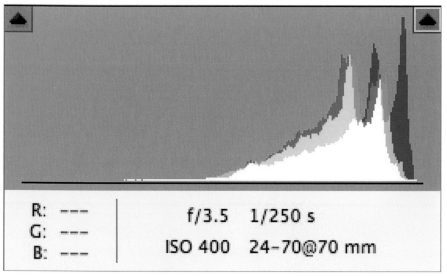

Image 5-4. The histogram of from Adobe Camera Raw shows the recorded data from the metering shot in which the white shirt filled the entire frame.

Metering White Tones for Manual Flash. We can use the same technique to meter for manual flash. By placing our brightest relevant tone (*i.e.,* the brightest part of our subject, such as a white shirt) in a specific place on our histogram, we can accurately set our flash exposure.

The histogram becomes quite an accurate method of metering for our manual flash if we use it to assess the exposure off a very selective area of our subject—here, the white shirt. For **image 5-5**, our model, Anelisa, was lit by manual flash in a softbox. As we have learned, manual flash exposure is controlled by the aperture and ISO settings we choose, the distance from the softbox to our subject, and the power setting on our flash. We can control any of

Image 5-5 (right). Anelisa was lit by manual flash in a softbox.

Image 5-6 (above). The histogram for image 5-5.

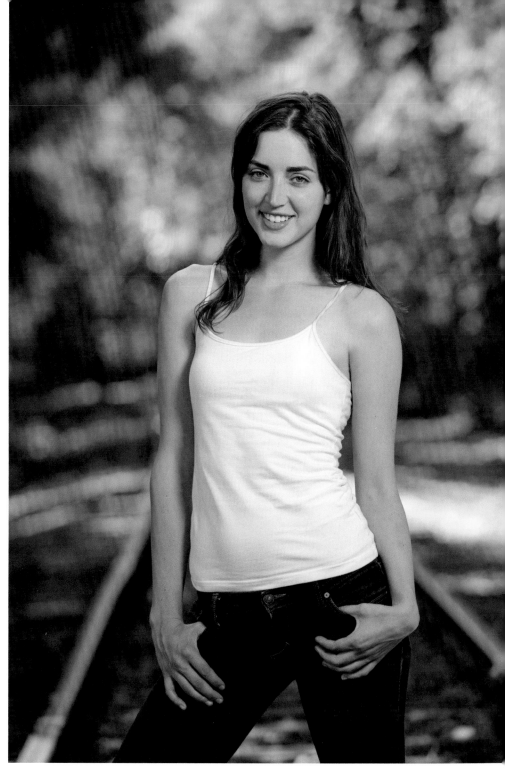

those four settings for our manual flash exposure. In this photograph, we have correct exposure; white appears as white and the skin tones look good. Let's see what the histogram can tell us.

The histogram (**image 5-6**) shows us the picture information that our cameras can capture. The left-hand side of the histogram shows the darkest tones; the right-hand side shows the brightest tones. The shape of the histogram varies a lot depending on the scene we're photographing. We can't really ascertain

much from a general histogram like this, since it includes our background and our subject.

When we only look at the brightest part of our subject (the white shirt), we can see that the histogram dips close to the right-hand corner (**image 5-7**). This means we have captured the brightest part of our subject accurately. This is the histogram on the Nikon D3—and the f/4 setting looks great according to the histogram.

If we increase the exposure, the histogram will shift. In **image 5-8**, it's right on the edge and is starting to spike. That's indicative of overexposure. If we moved to the blinking highlights display, we'd see that the image is indeed

Image 5-7. The histogram for just the white shirt.

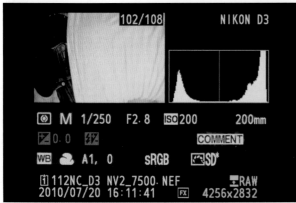

Image 5-8. Increasing the exposure shifts the histogram to the right.

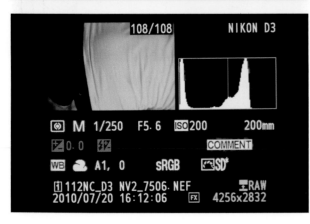

Image 5-9. Reducing the exposure shifts the histogram to the left.

overexposed. (*Note:* For this example, I changed the aperture. But we'd get the same results if we changed our ISO, moved the light closer, or changed the power setting on the flash).

Shifting the exposure down, again by adjusting the aperture, we can see that the white areas now appear gray. The histogram (**image 5-9**) is also shifted too far to the left for a tone that is bright.

Naturally, we can do exactly the same thing with Canon cameras. **Images 5-10** through **5-13** show the histogram display for the Canon 5D, looking at exactly the same setup of Anelisa lit with the softbox. As we shift our apertures, our exposure changes and the histogram shifts. The f/4 setting looks good, as does the f/3.5 setting—but the final image (at f/2.8) might appear a touch too bright on our monitors. The point at which our histogram tells us we're not overexposing our whites (nor underexposing them) is where we have our optimal settings. You can see in the camera display for the f/2.8 exposure that we're getting blinking highlights that tell us we're overexposing. (However, even this is within the margins of what a JPEG can handle in postproduction correction. For a RAW file, this would be no problem at all; the information is there.)

In this example, we again changed our aperture to affect our manual flash exposure—but we would have achieved the same result with any of the other three controls for manual flash: ISO, distance from the light source to the subject, or the power of the flash

Using this strategy, we can do multiple test exposures looking *only* at the brightest relevant tone. The settings at which our histogram dips just into the right-hand corner of the histogram will be our correct exposure. This technique is just as accurate as using a flash meter.

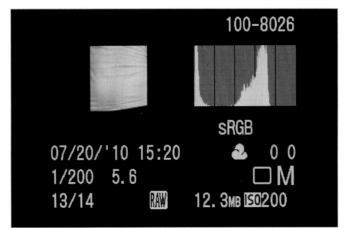

Image 5-10. Canon histogram for Anelisa image at f/5.6.

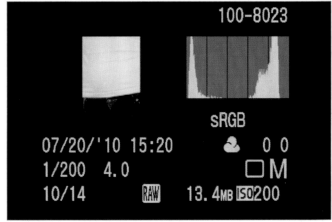

Image 5-11. Canon histogram for Anelisa image at f/4.0.

Image 5-12. Canon histogram for Anelisa image at f/3.5.

Image 5-13. Canon histogram for Anelisa image at f/2.8.

6. Balancing the Flash with the Ambient Light

We have two broad ways in which we can use flash with ambient light: we can add subtle fill flash to the existing light; or we can overpower the existing light and use flash as the main light. In between those two scenarios we have a range of possibilities. Much of this chapter hovers in that "in between" area—that intersection where flash augments the available light by just enough. First, however, let's consider those two broad scenarios.

TWO BROAD SCENARIOS

If We Just Need Fill Flash. If we already have correct ambient exposure for our subject, regardless of our background, then we need to have our flash 2 to 3 stops under the ambient light exposure to use it for fill.

If we decided to use manual flash, we'd meter for our manual flash to give us exposure 2 or 3 stops below what we have set our cameras to for our background. For example, if we had settled on f/4 at 100 ISO, then we'd set our flash so that our flash meter tells us we need an aperture of f/2 (or thereabouts) for a correct exposure. Shooting at f/4 will underexpose our manual flash (f/2), making it function just as a fill light source.

If we used TTL flash, our flash exposure compensation would be in the region of –2 or –3 EV. With TTL flash, we have to keep in mind the tonality/reflectivity of our subject/scene; this will affect our flash exposure.

If We Need Flash as a Main Light. Another approach to using flash is to intentionally underexpose the ambient light by 1 stop or so, then use flash to attain the correct exposure. This lets us create great directional lighting, since our flash functions as the main light.

With manual flash, the simplest approach is to use a flash meter to figure out the correct flash exposure.

With TTL flash, you'd set the flash exposure compensation in the region of 0 EV. Against a brighter background, you might be using +1.0 EV—or perhaps higher, like +1.7 EV. As discussed in chapter 4, you will be basing your exposure settings on how you want your background to appear. Although TTL flash might be fast and easy to work with, in this case it may not be as predictable as manual flash. You will have to check your camera's preview to see your results, adjust your flash exposure compensation, then rely on the latitude of the RAW file to take up some of the slack.

THE SIMPLEST APPROACH

Balancing flash and ambient exposure is something that many newer photographers struggle with. The big hurdle seems to be the basic starting point: how do you decide on the exposure for each—for the ambient light and for the flash?

The simplest approach for me, when I work in fairly flat and even ambient light, is to underexpose the ambient light by a certain amount, then add flash for the correct exposure. So how much do we underexpose the ambient light by? Well, it depends. Usually 1 stop is good; 2 stops can also work. You've probably seen some of the images in fashion and music magazines where the subject is in a pool of light surrounded by an dark cityscape; for these, the photographer underexposed the ambient light by 2 to 3 stops. So we have quite a bit of leeway—which should ease some of the anxiety!

This is exactly the technique we used during part of a flash photography workshop with model Anelisa, who was posed in an urban setting (**images 6-1** to **6-3**). I could have used manual flash here but chose TTL for a faster setup. I

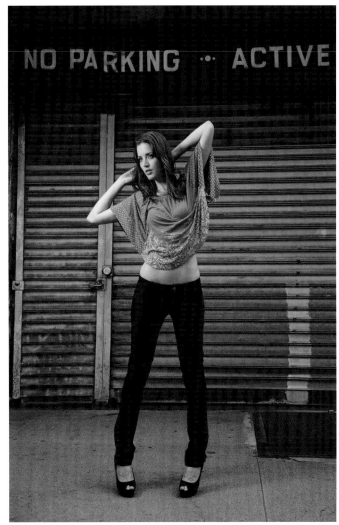

Image 6-1. ($^1/_{200}$ second at f/3.5 and 200 ISO; TTL flash at –0.7 EV)

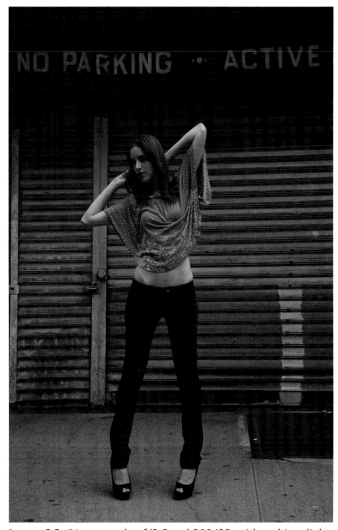

Image 6-2. ($^1/_{200}$ second at f/3.5 and 200 ISO; with ambient light only)

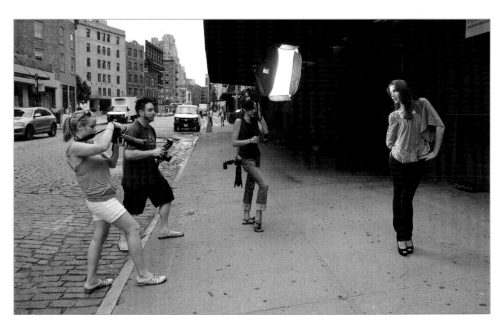

Image 6-3. A pullback shot shows how the softbox was placed.

had to dial down the flash exposure due to the darker tones in the photo. In **image 6-1**, the flash was disabled, so you see just the ambient light, underexposed by around 1 stop. In **image 6-2**, the flash (with a softbox) was added to create a more dynamic lighting pattern and give clean open lighting on our model's features. **Image 6-3** is a pull-back shot to show how the softbox was placed. It will also give a better idea of the available light in general.

Underexposing the ambient light by 1 stop and then adding flash is just one possible scenario—one lighting recipe. This approach won't apply to every situation you might encounter, but it's a good starting point.

Now, let's look at an example where we have to apply this method a little differently. When photographing model Jessica in Times Square, the neon lights in the background were flashing so much that they were essentially unpredictable. Positioning her so that she was shaded, compared to the bright background, allowed me to expose correctly for her with my flash in a softbox (**image 6-4**). **Image 6-5** shows a comparison without flash, giving a sense of how the brightness of the background changed. As we can clearly see here, without flash providing light on our model, she would be completely underexposed.

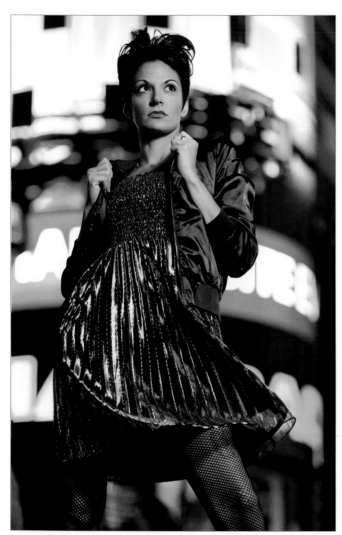

Image 6-4. ($^1/_{250}$ second at f/2.8 and 200 ISO; TTL flash at –0.3 EV)

Image 6-5. ($^1/_{250}$ second at f/2.8 and 200 ISO; with ambient light only)

With the amount of light there in Times Square, we would have been able to get well-exposed images at a wider aperture and higher ISO—even without the use of flash. **Image 6-6** was taken with the Nikon 200mm f/2 AF-S VR lens, using only the available light. I specifically placed the model, Lauren, so that enough light fell on her face to give me a correct exposure at a shutter speed where I could still hand-hold my camera (no tripods are allowed in Times Square without a permit).

For **image 6-7**, I positioned Jessica so that she would be in the dark relative to the brighter background (**image 6-8**). This allowed me to use flash without much concern for the ambient light producing any weird color casts on the model.

In deciding on my basic exposure, I simply needed the background to appear light enough. I have no idea how you'd use a handheld meter for these neon lights; instead, I checked my camera's built-in meter against a portion of the background that didn't contain too many dark areas or overly bright areas. I just wanted a general idea of my settings. Then I took a few test shots (without flash) and checked the camera's preview until I was happy with the way the

Image 6-6. ($^1/_{200}$ second at f/2 and 800 ISO; ambient light only)

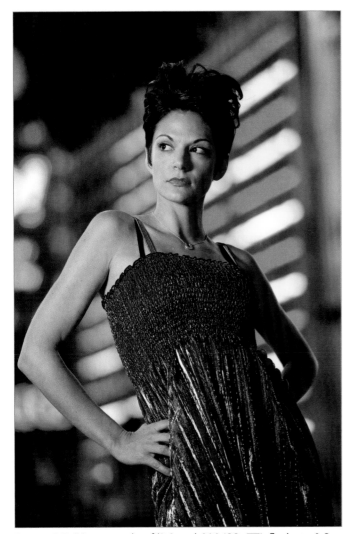

Image 6-7. ($^1/_{160}$ second at f/3.2 and 800 ISO; TTL flash at –0.3 EV)

Image 6-8. ($^1/_{160}$ second at f/3.2 and 800 ISO; with ambient light only)

background appeared. This is an iterative process with the starting point given to us by our approximate camera readings.

Then, I added flash. I needed a flash output of f/3.2 at 800 ISO. I had two options here:

1. Use manual flash with a handheld meter to determine the flash exposure (as opposed to just guessing and checking the LCD preview).

2. Use TTL flash, allowing the technology to get me close to correct exposure, then nudging the exposure up or down according to what I saw on the camera previews. This is a bit more "hit and miss" than using manual flash and a flash meter, but it works and gets us to correct exposure fairly quickly. It might also be a more flexible way of shooting than using manual flash, if I wanted to change position and angles.

I had a wide margin here as to what would work. (Remember, changing the distance from the light source to the subject changes the manual flash exposure.) Since the model was shaded compared to the background, there is a range of settings that would have worked. I would also have had success with images in which the background was about 1 stop brighter or darker.

A similar approach would be use to create something like **image 6-9**, where I wanted the evening sky to register and a bare minimum of detail to show on buildings and trees in the background.

When you work on location, you start off with your ambient exposure as your base exposure. Whether you underexpose your background or allow it to be brighter—that's your choice. But that's the starting point when figuring out how to balance flash and ambient light.

Looking at **image 6-9**, this means that you would take your background into account when figuring out your basic camera settings. You would then expose for the background and use flash (whether in manual or TTL mode) to expose correctly for your subject. Since I chose TTL flash exposure, the flash exposure followed my choice of aperture and ISO. If I had shot with manual flash, I would have used a flash meter to set my flash output to match my choice of aperture and ISO for the particular distance at which I had my light set up.

The key point here is that, once again, a variety of setting combinations would have produced a great exposure for the background. The images would have looked different from each other because of that—but they would all have worked. And that should give you a major sense of freedom!

Image 6-9 (facing page). A medium softbox was added to camera left. I used a Q-flash T5D-R, but a speedlight in the softbox would have worked just as well in this case. ($^1/_{250}$ second at f/3.5 and 500 ISO; TTL flash)

When you work on location, you start off with your ambient exposure as your base exposure.

FINDING YOUR BASIC SETTINGS

What were your settings? This is question that I am often asked about various images. Quite often, the answer is surprising: The specific values don't really matter.

Sometimes the specific settings are of importance—but usually they are much less significant than the *method* of getting to correct exposure of the ambient light and the flash. The "how" is far more important than just a listing of seemingly random figures.

For **image 6-10**, I used manual flash: two flashguns, each in a softbox. These were held close together, but each was pointed at one of models. Since I used manual flash, there were then four factors controlling the flash exposure: the ISO; the aperture; the power setting on the flash (I kept this to ½ of full power for quicker recycling between shots); and the distance to the subject. Since the flash was in a softbox (held aloft on a monopod by an assistant), the flash exposure could be controlled by moving the softbox closer to, or farther from, our subjects. The distance was the most easily-accessible variable with which to control the flash exposure independently from the ambient light.

First, however, I had to start with the ambient exposure. The sky was still fairly bright, therefore 100 ISO made most sense. The ISO could have been higher if I needed more depth of field. Since ISO affects both ambient and flash exposure, any reasonable ISO would have been okay—as long as we didn't run out of usable apertures.

As noted in a previous chapter, we get the most efficiency from our flash when we shoot at the maximum flash sync speed. For many cameras this is $\frac{1}{250}$ second (check for your specific camera), so that's the setting I used. (*Note:* Shutter speed is our independent control for the ambient light and has no direct effect on flash exposure. When you work in bright conditions, the use of maximum flash sync speed is most often the key to balancing flash with daylight.)

Then, an appropriate aperture was chosen to expose correctly for the sky. In this case, I created a dramatic sky by underexposing slightly. At this point, I had established the correct ambient exposure.

Finally, the softbox was held close enough—or far enough—for proper flash exposure on the subject.

Essentially, this whole procedure becomes an easy shortcut. Bright conditions? Go to maximum flash sync speed. You might as well then go to 100 ISO. (Or 200 ISO, on some DSLRs.) Then, find your aperture for correct ambient exposure with these other two settings. Finally, find your correct manual flash exposure by setting the power and distance. Using this approach, what seemed like a confusing mess of numbers and settings will logically fall into place for many of the scenarios we find ourselves working in.

Image 6-10. ($^{1}/_{250}$ second at f/3.5 and 500 ISO; two manual flash units in softboxes)

REINFORCING THE IDEAS

To reinforce many of the ideas we've discussed so far, let's look at another specific image, analyzing our options and seeing if we can make sense of it all. We'll use a simple portrait as an example so that the things we have to consider and balance are more obvious (**image 6-10**).

A Pleasing Background. My starting point with a photograph most often involves finding an interesting, complementary, or even neutral background, and then positioning my subject in relation to that background for a pleasing look. How do you know if it is a pleasing look? Well, that's open to interpretation— and it is what makes every photographer unique. A good strategy is to eliminate anything that is distracting or doesn't add to the final image. Look at the edges of your frame. What you exclude is just as important as what you include. Most often, it's best to simplify the composition by eliminating clutter.

Even Lighting. When I work on location with a model or a couple, I position them in even lighting. It makes my job easier if there are no hard shadows or strong dappled light on their faces. If you're more adventurous and have a specific vision that you're chasing—and you need (or can work with) strong uneven lighting—then go for it. But a simpler approach, where we control the light that falls on our subject, is easier—and with our options simplified, it becomes easier to balance the flash and ambient lighting.

Exposure Metering. When it comes to exposure, if our subject is shaded we start with the background. We could work with handheld meters, but this would be impossible with a background of dappled, sunlit leaves like we have in **image 6-10**. It will be much easier to use the camera's built-in meter. Now you have to decide how you want your background to appear. Do you want it overexposed to an extent? Maybe you want a summery, airy feel to it. Or perhaps you're looking for a high-key effect. Or do you want to overexpose it to such a degree that you lose detail (good for simplifying a distracting background)? You could also underexpose it. The choice really is yours.

In **image 6-10**, I looked through the viewfinder and let the meter show overexposure by +0.7 stops. I could have chosen a zero reading or I could have blown out the background even more—or underexposed it. In this case, I wanted the background to be slightly brighter than what a zero reading would have given. There are many settings that would work—but there is a limit: you cannot choose settings that will overexpose your subject. (That should be an obvious limit, though.)

In this case, I ended up only needing a touch of fill flash on my model—just the lightest kiss of flash to open up any shadows on her face. My final settings were $\frac{1}{250}$ second at f/4 at 100 ISO with manual flash. My flashgun was used in a softbox and triggered with Pocket Wizard radio slaves.

Image 6-10 (facing page). A simple portrait to analyze the flash and ambient lighting.

When it comes to exposure, if our subject is shaded we start with the background.

Flash Sync Speed. By now, my choice of the maximum flash sync speed should be an obvious one: it gave me the most efficiency from my flash without going into high-speed sync mode. (Additionally, I was using Pocket Wizard Plus II units. These older units don't allow for wireless TTL control or high-speed flash sync, so I couldn't exceed the maximum flash sync speed.)

Image 6-11. (/250 second at f/10 and 200 ISO; manual flash in a softbox to camera left)

FILL FLASH IN BRIGHT LIGHT

This photo session of Denise and Phil (**image 6-11**) is a scenario where the subjects were well lit by ambient light. I only needed to use flash as fill to bring up some shadow detail. This is a situation where I'd meter for the subject—with little regard for the background.

I used my camera's built-in meter to get my basic ambient exposure. I then double-checked my exposure to see where Denise's white dress would fall on my histogram (and also make sure there were no blinking highlight warnings). I could also have used the Sunny 16 rule as a mental starting point—keeping in mind the sun was getting lower—and then reviewed a quick test shot on camera's LCD.

If the subjects were already well-lit and properly exposed for, then adding the same amount of light from my flash (*i.e.*, the "proper" exposure, as if there were little available light) would mean I was adding double the amount of

Image 6-12. This photo was taken at $^1/_{1000}$ second at f/6.3 and 200 ISO. If we juggle those values a bit, we'll see that this is close to Sunny 16 settings—usually a good starting point when working in bright light. No flash was used here.

light necessary for a proper exposure. Therefore, I'd just add fill flash in this situation, setting it 1 stop (or more) under the ambient light. In this case, the flash was a Q-flash and softbox held off to the left of the camera. There is no overexposure though, since the flash exposure was lower than the ambient exposure.

Image 6-12, also of Denise and Phil, was shot with only the available light. Here I didn't expose for my subjects per se, but I did make sure that they were positioned such a way that they would stand out from the background. My exposure was based on the overall scene, not a specific tone. I didn't want the bright sun in the viewfinder to affect my exposure, so I kept to the manual exposure mode and used the LCD preview to evaluate my results.

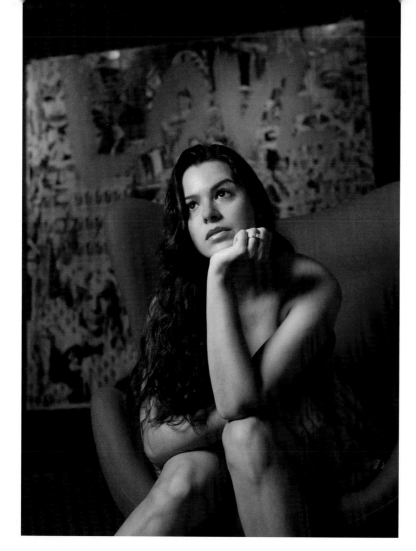

Image 6-14 (left). The image with an un-gelled flash. Note the orange color cast on the background. ($^1/_{250}$ second at f/5.6 and 200 ISO; manual flash fired with Pocket Wizards)

Image 6-15 (facing page). The image with a gelled flash. ($^1/_{250}$ second at f/5.6 and 200 ISO; manual flash fired with Pocket Wizards)

GELLING THE FLASH FOR TUNGSTEN

The lighting inside buildings is predominantly artificial, so I usually gel my flash to balance it with the existing light. With tungsten lighting, I use either a full or ½ CTS gel to bring my flash's white balance, which is around 5400K, in line with the warmer available lighting (around 2900K). You can also use CTO gels, which can be purchased as a set.

When the subject is shaded, compared to a well-lit incandescent background, a ½ CTS gel helps bring the flash closer to the tungsten white balance while retaining some of the warmth of the ambient light. When your subject is lit both by incandescent light and flash, a full CTS gel is essential for avoiding discordant color casts.

For my portrait of Oktavia (**images 6-14** and **6-15**), I wanted the background to be neutral and not have the distinct orange color cast of tungsten lighting. **Image 6-14** was taken with an ungelled flash; notice the orange color cast on the background. **Image 6-15** was taken with a full CTS gel over the head of the flashgun, which changed the 5400K color balance to around 2900K. For this image, I set my camera's white balance to tungsten. The flashgun was in a softbox which was held up to camera left.

Image 6-16. A flash head with a ½ CTS gel taped to it.

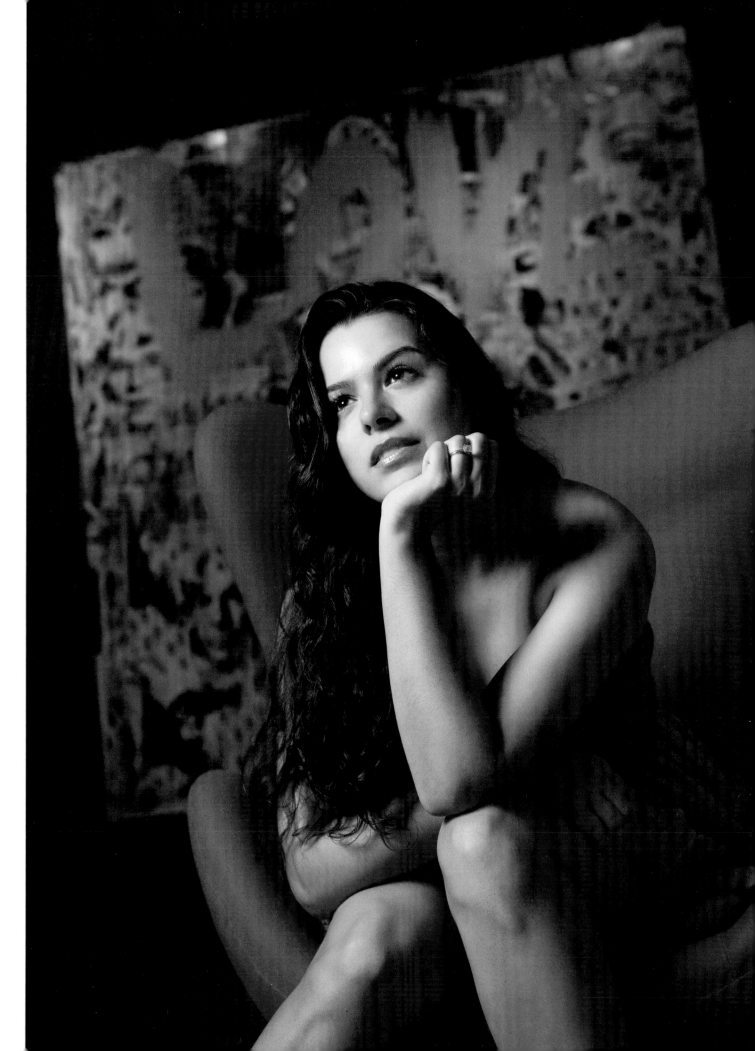

7. Positioning the Flash

PLACING A SOFTBOX

A softbox is generally placed at about a 45 to 60 degree angle to the camera's left or right. The light is typically about 30 degrees above the subject's head. This puts enough light in the eyes of the subject and directs it at an angle that makes visual sense (with the light coming from higher than the subject's view). Essentially, you want to make sure that the cone of light coming from the softbox hits your subject's head and shoulders.

Fortunately, a softbox is a forgiving light source. You have a fair amount of play when it comes to the height and angle. In fact, the larger your light source is, the more forgiving it is in terms of placement. In comparison, if you use direct off-camera flashguns without diffusion you will need to be more precise in your placement of the flash.

Image 7-1. The lighting here was a flashgun in a softbox, held aloft on a monopod. ($^1/_{250}$ second at f/8 and 200 ISO; TTL flash at –0.3 EV)

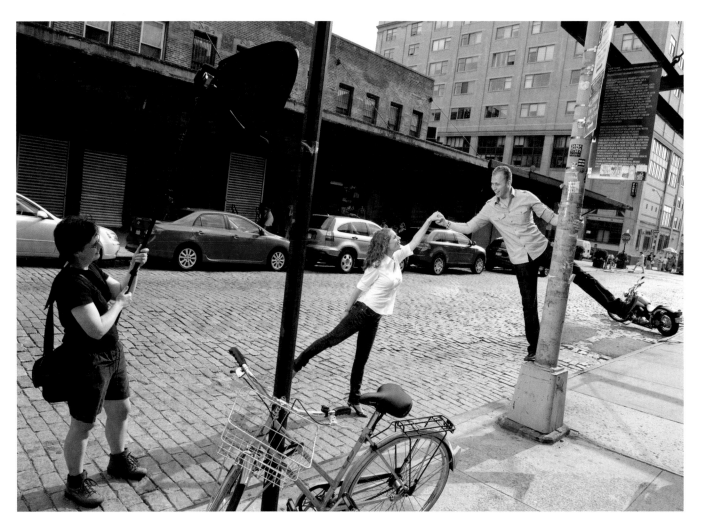

Image 7-2. A pull-back shot showing the setup for image 7-1.

Let's look at an example. During a photo session with Christina and David (**image 7-1**), I needed to match the bright sunlight, so I worked at the maximum flash sync speed to get the most power from my flash. The light was so bright that it was getting to the edge of what the flashgun was capable of when diffused with a softbox. I used wireless TTL flash, with the master flashgun on my camera and aimed at the slave flashgun mounted on the softbox. In **image 7-2**, you can see the placement of the softbox, held aloft on a monopod by an assistant. To shoot the final image, I was standing right next to the bicycle. (*Note:* The final image had some editing done to remove distracting background elements such as the motorbike.)

When combining a single off-camera light source (such as the softbox and flashgun combination used in **images 7-3** through **7-5**; next page) with ambient lighting, it also becomes necessary to position the model (here, Camille) in such a way that the light from the flash strikes the subject from a sensible angle. Generally, what I look for is that the light opens her features that are in shade. I also want some light on the model's eyes, without a heavy shadow under the brow.

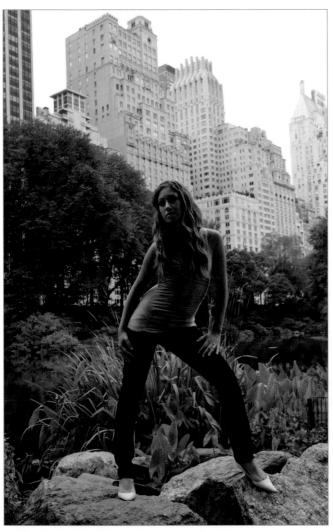

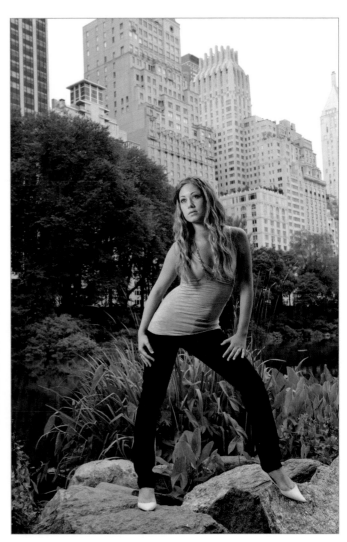

Image 7-3. This image, with ambient light only, shows the direction of the existing light (from camera left).

Image 7-4. A softbox was added to camera left to blend with the natural light while opening up the shadows.

Image 7-5. The setup for the final image.

FEATHERING THE LIGHT

In the previous example, I positioned the light with the central "sweet spot" from the softbox pointed at my subject's features. Sometimes, though, we need to control the position of our softbox more precisely—and control the spread of light from the softbox. The following image sequences (**images 7-6** to **7-9** and **images 7-10** to **7-13**) show situations where I feathered the light from my softbox.

In **images 7-6** to **7-9**, I wanted to prevent a hot-spot of glare from appearing on the metallic door in the background. Positioning the softbox as I normally

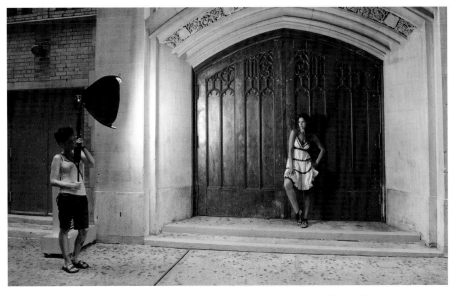
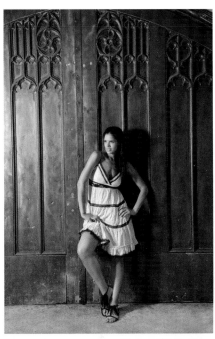

Images 7-6 and **7-7.** Glare from the flash is evident on the metallic wall.

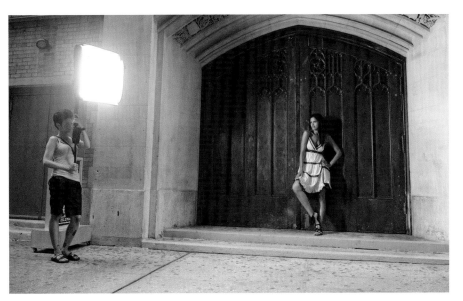
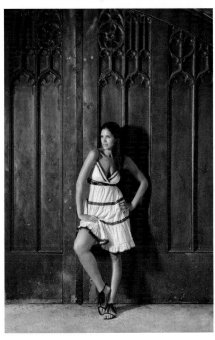

Images 7-8 and **7-9.** Feathering the flash eliminated the glare. ($^1/_{200}$ second at f/4 and 400 ISO; TTL flash at +0.7 EV)

would resulted in the light from the softbox being directly reflected toward the camera (**images 7-6** and **7-7**).

By angling the softbox away to a fair extent (**images 7-8** and **7-8**), I made sure that most of the light reaching the model was from the light from the edge of the softbox's spill—and that the glare-causing light did not strike the door. (*Note:* A minor problem now is that we do see the shadow of the softbox being cast.)

In the second example (**images 7-10** to **7-14**), I feathered the light from my softbox to avoid too much light spilling on the top part of the wooden structure. The idea was to accentuate the model, Stacy, by having the light more concentrated on her. This technique should be apparent from the photos. I simply rotated the softbox away from the wall, making sure I still got enough light on our model.

Image 7-10 (left). Here is the scene with the flash disabled.

Image 7-11 (right). Directing the flash at the model as I normally would spilled too much light onto the building above her.

Image 7-12 (facing page). Feathering the light kept the emphasis on the model and created a pleasing lighting pattern on her face. ($^1/_{125}$ second at f/5.6 and 200 ISO; TTL flash at –0.7 EV)

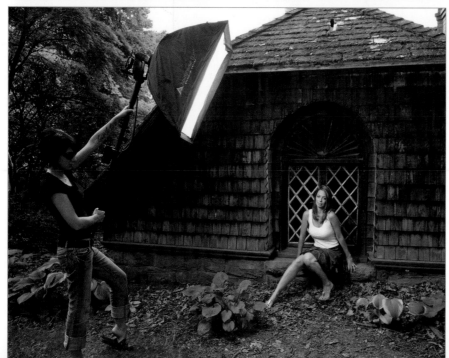

Image 7-13 (left). A pull-back shot showing the placement of the softbox for the final image.

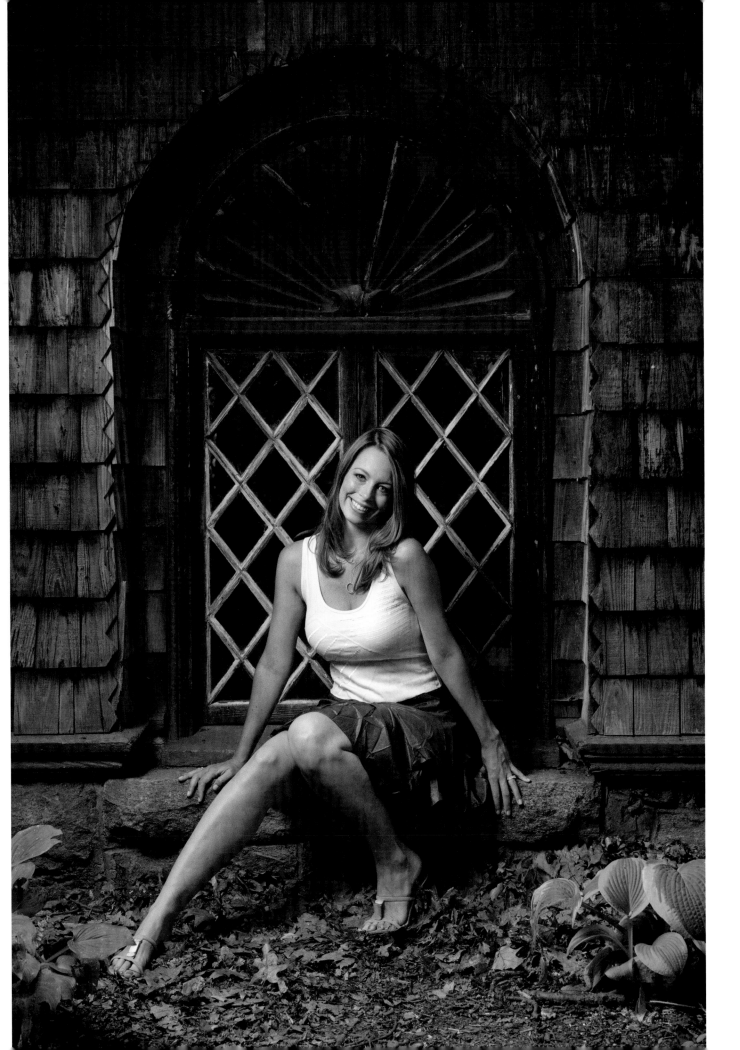

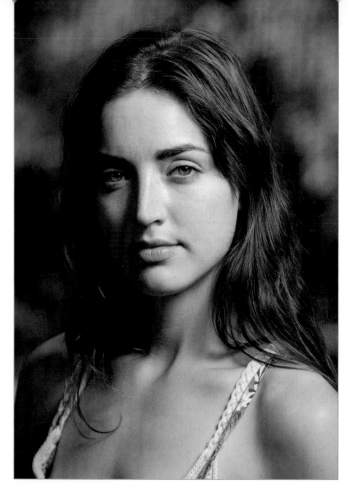

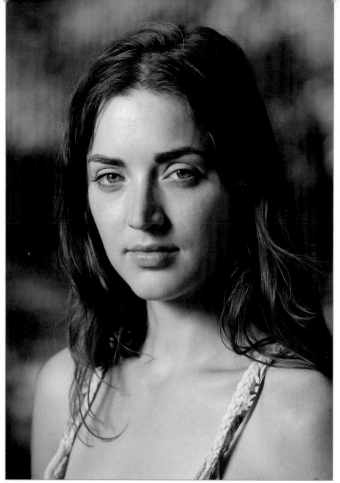

Image 7-14. Broad lighting. ($^1/_{250}$ second at f/5.6 and 200 ISO; manual flash fired with Pocket Wizards)

Image 7-15. Short lighting. ($^1/_{250}$ second at f/5.6 and 200 ISO; manual flash fired with Pocket Wizards)

POSITIONING THE OFF-CAMERA FLASH FOR PORTRAIT LIGHTING

There are two basic ways to position a softbox or umbrella as the main light on your subject. The first is called *broad lighting*, which occurs when the light mainly hits the side of the face turned toward the camera (the wider side of the face from the camera's view). The other is called *short lighting* and occurs when the light mainly hits the side of the face turned away from the camera (the narrower side of the face from the camera's perspective).

These basic lighting patterns can clearly be seen on the features of model Anelisa in **images 7-14** and **7-15**. In **image 7-14** (broad lighting), the flash in a softbox was positioned to camera right, illuminating the side of her face turned toward the camera. In **image 7-15** (short lighting), the flash was placed to camera left, illuminating the side of her face turned away from the camera. Generally, short lighting is more interesting and dynamic looking. It is also more slimming than broad lighting, and is regarded as a more feminine lighting type. Broad lighting is regarded as a more masculine type of lighting.

8. Overpowering the Sun with Flash

As photographers, one of the most difficult existing light situations we can find ourselves working in is harsh sunlight. Fortunately, there are ways we can overcome many of the unflattering qualities of sunlight by how we position our subject, how we position ourselves in relation to our subjects, and (in many cases) the addition of off-camera flash.

WORKING WITH THE SUNLIGHT ALONE

Images **8-1** and **8-2** were created during a photo session with Kristy and Tom. For the session, I used the harsh sunlight to my advantage without using off-camera lighting to balance it out. This required specific attention to placing the subjects in relation to the light.

For **image 8-1**, I had the couple look in the general direction of the light—but not directly into the light. This gives open light on their features, even if the contrast is quite high. The other possibility was to shoot against the sun, using it as a kind of rim lighting on the subjects. In **image 8-2**, the sun was fairly low, so it did help. Allowing the lens to flare also added to the mood of the photograph.

In both these images, the existing light wasn't ideal—but careful placement of the camera and the subjects let me use it to my advantage.

Image 8-1 (left). Having the subjects look in the direction of the light puts good lighting on their faces.

Image 8-2 (right). Shooting against the light creates a stylized, but appealing, look.

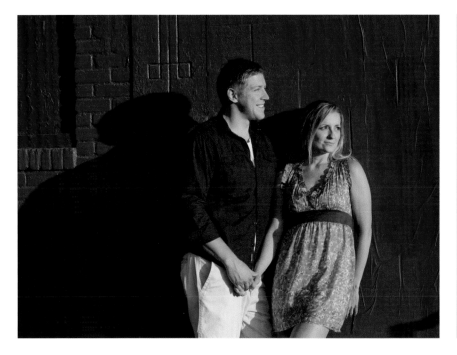

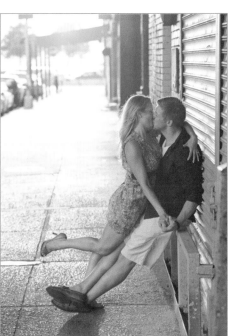

ADDING FLASH

We aren't always able to make use of the strong sunlight. In those cases, adding off-camera flash can help us balance out the strong, uneven lighting.

To get rid of the uneven sunlight falling on our model in **image 8-3**, I had to add at least as much light on her as the brightest areas lit by sunlight. My exposure was set to ¹⁄₂₅₀ second at f/13 and 200 ISO. We can see from the bright patch of light on her shoulder that we're at the edge of an acceptable exposure. If I'd used a wider aperture, higher ISO, or slower shutter speed, I'd have started to lose detail in the sunlit areas.

For **image 8-4**, I used a softbox on a monopod with a slaved flashgun attached. The slaved flash was triggered by a master on-camera flash with its own output disabled so it didn't add anything to the final exposure. Ideally, to lose the dappled or uneven or harsh available light, we need to underexpose it by around 3 stops. Then the flash exposure will completely dominate.

In **image 8-4**, the model's pose helped to hide the residual uneven light due to her face being in shadow and her shoulder being in sunlight. In **image**

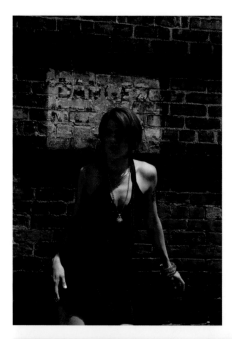 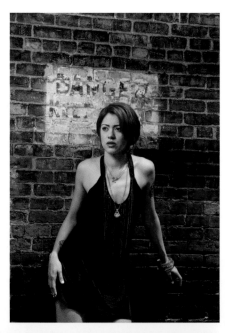

Image 8-3 (left). The ambient lighting on the subject was uneven—and unattractive. (¹⁄₂₅₀ second at f/13 and 200 ISO)

Image 8-4 (right). Adding flash evened out the lighting.

Image 8-5 (left). The setup for image 8-4.

Image 8-6 (facing page). Even with two baffles removed from the softbox, the flash couldn't produce enough power to completely override the sunlight.

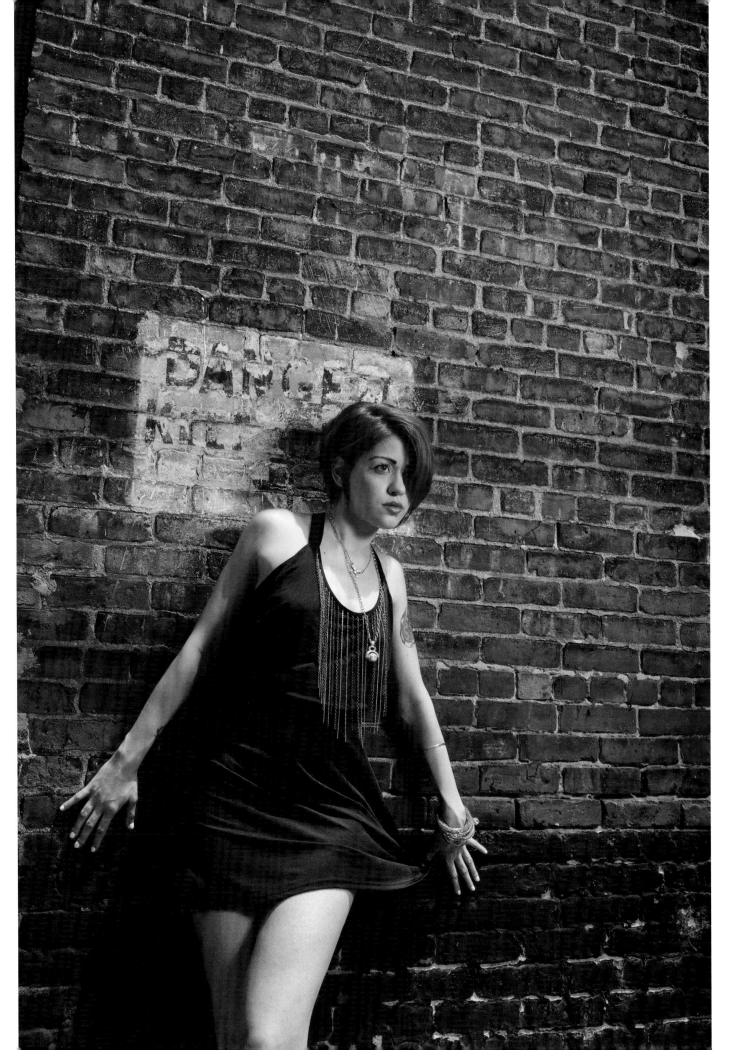

8-6, however, we can see the uneven lighting below her chin, casting strange shadows. Even though I had pulled out one of the two baffles inside the soft-box, it still couldn't deliver enough light to completely override the sunlight. In other words, I set an aperture and ISO combination where the daylight still registered to a large extent.

How could we get enough light onto the subject from the flash? We have to, once again, look at the four things that control manual flash exposure: aperture, ISO, the distance from the flash to the subject, and the power of the flash. In that equation, our aperture is effectively chosen for us by our desire to underexpose the bright available light by a certain amount. In effect, our ISO is also chosen for us (whether 100 ISO or 200 ISO) by the bright light. Therefore, to override the daylight, we either need to get our flash closer to our subject or we need to get more juice from our flash. If we're already at full power from our flash, then we can only adjust our flash exposure by bringing it closer to the subject. (*Note:* We could also consider zooming in our flash head to give us more condensed power—if we can live with the possibility of light fall-off at the edges of the frame.)

For **images 8-7** through **8-9**, I photographed a model (Lea) at the Brooklyn Bridge in very bright light. I wanted to incorporate the model as part of the ur-ban landscape, so I shot wide and allowed the scene some room. When work-

Image 8-7. Direct flash was the only way to overpower the bright sunlight. ($^1/_{250}$ second at f/18 and 200 ISO; direct manual flash)

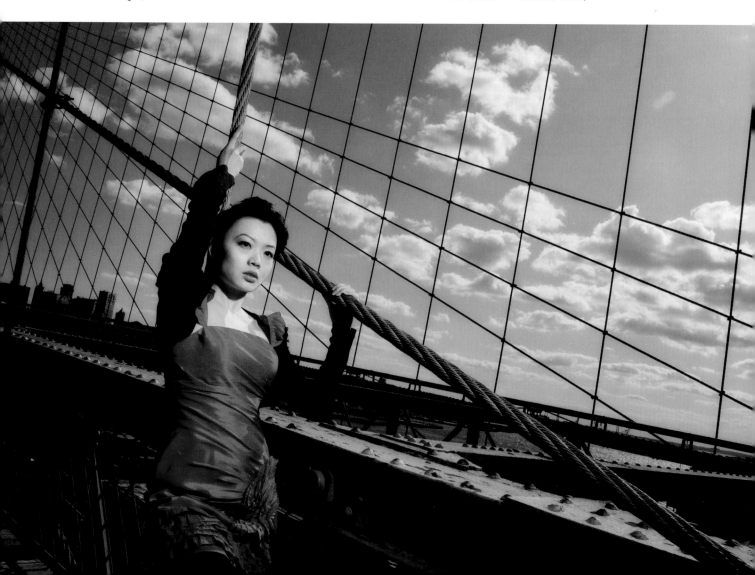

Image 8-8 (left). ($^1/_{250}$ second at f/18 and 200 ISO; direct manual off-camera flash)

Image 8-9 (right). ($^1/_{250}$ second at f/16 and 200 ISO; direct manual off-camera flash)

ing outdoors, my normal approach is to use a softbox (or some other modifier) so that my flash is more diffuse. Here, however, I wanted to use something slightly different than my usual softbox method. This approach was also necessary to achieve enough power to override the bright daylight (since I only had one Quantum flash with me and nothing large).

Image 8-7 was taken at $^1/_{250}$ second at f/18 and 200 ISO. That kind of aperture isn't attainable when you stuff a flashgun or Q-flash inside a softbox. You'd need a much more powerful flash or a studio strobe. Therefore, it had to be direct flash during this photo shoot. Taking it off-camera and positioning it to augment—and even overpower—the sunlight falling on the model resulted in a look that is quite dramatic. The same results could as easily have been achieved with a speedlight. With a larger flashgun (SB-900 or 580EX II), settings like f/16 at 200 ISO would translate into a working distance of about 3 meters [10 feet] from the flash to the model. This is a workable distance. **Images 8-8** and **8-9** show you some variations from the same session using the same setup.

Images 8-10 and **8-11.** ($^1/_{250}$ second at f/10 and 200 ISO; wireless TTL flash at +1 EV)

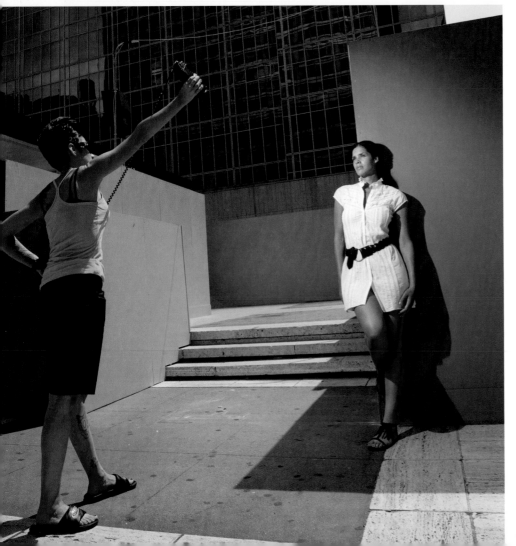

I was drawn to the urban setting in **images 8-10** and **8-11** by the bold colors of the walls that were put up during construction on the site. The light was very bright with deep shadows—the contrast was strong. To get enough light from the flash on our model, Addriana, I had my assistant hand-hold a flashgun high up. By using *direct* off-camera flash, instead of flash through the diffusion of a softbox, I was able to get enough light on the model to overpower the sunlight.

Image 8-12 shows another example where I had to get maximum power from my flashgun to match the bright sun in the sky. Since I knew I would

Image 8-12. ($^1/_{250}$ second at f/16 and 100 ISO; direct manual off-camera flash)

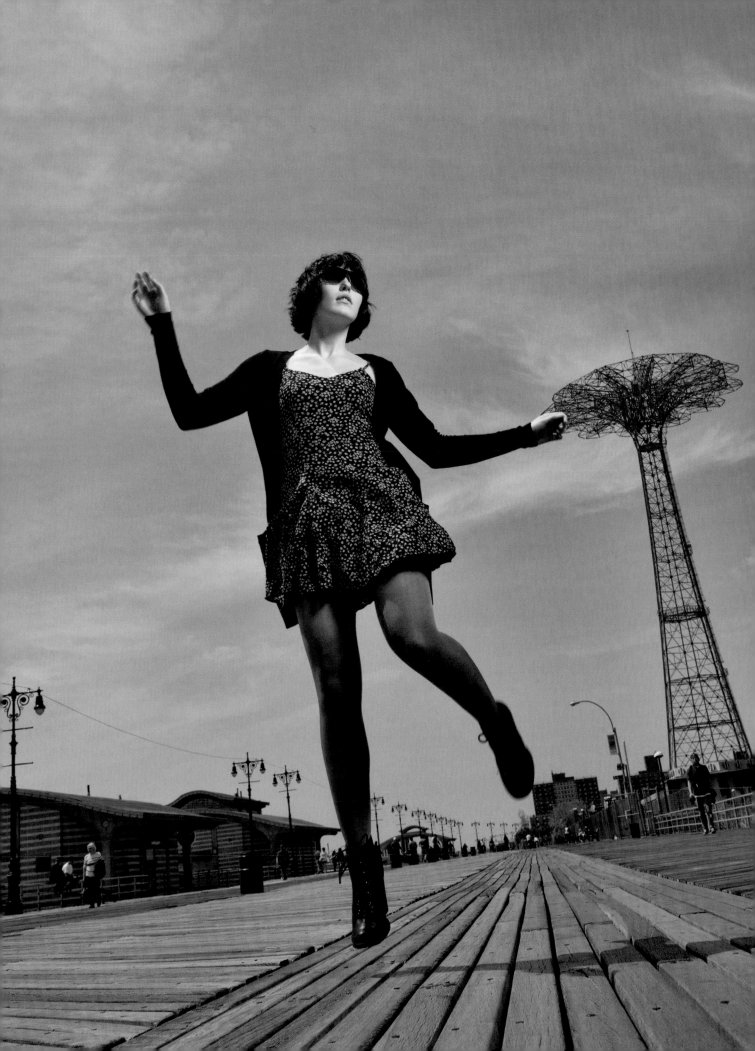

Image 8-13 (facing page). The model was lit with a beauty dish to camera right. The exposure was ¹/₂₅₀ second at f/11 and 200 ISO—but she moved closer to the beauty dish when she jumped, so I had to adjust the exposure by –1.5 EV in processing the RAW file.

Image 8-14. The pull-back shot for image 8-13. That's Frank Doorhof flat down on the boardwalk. It's not comfortable. There are splinters.

want the absolute maximum power from my flash (for the zoom setting it was at), I had to shoot in manual. Then it just became a matter of finding the distance at which the flash exposure on the subject was correct.

Alternately, when working in very bright light, a more powerful lighting setup can be used. The lighting in **image 8-13** was with a Profoto AcuteB 600R power pack that I use when I need a lot of juice to match bright sunlight. It delivers 600 Watt-seconds—about four times more than a flashgun. The light modifier was a Profoto beauty dish. The beauty dish provides a dramatic look and is an efficient light modifier because it concentrates the light. This helped to counteract some of the harsh shadows of the sun. (*Note:* Initially, I didn't like that her hand was "touching" the Parachute Jump in the background. I also wanted more separation between her feet and the ground—and didn't like how her toe was "touching" the building in the background. But looking at this image again, I decided it hinted at a super-hero theme, with the model towering over the background structures.)

Image 8-15 is another example where I used a powerful on-location lighting setup so that I could still employ a softbox with my flash. The sunlight on Coney Island was pretty harsh during my photo session with this couple, and I needed to clean up the sun's harsh shadows by adding flash.

Knowing that the Sunny 16 rule states that broad daylight meters in the order of 1/$_{250}$ second at f/11 and 100 ISO, I knew I'd either have to shoot with a bare flashgun or use a much more powerful strobe with a softbox. For this image I used the Profoto AcuteB 600R lighting kit with a 2x3-foot Profoto softbox set up to my right. Even though it is a fairly powerful on-location lighting setup, I had to shoot at full power to get f/11 at 100 ISO through the double baffle of the softbox.

I placed the softbox and flash to come in from the same direction as the sunlight, adding as much light as the sun. My intention was to clean up the shadows caused by the sunlight. This, in turn, underexposed the background by 1 stop, thereby saturating the sky. (*Note:* A neutral density filter is an obvious solution here; read on for details.)

And, yes, I can see the effects of diffraction from shooting at f/22. There's definitely more softness than I would have had at f/8. As for the amount of dust bunnies that also rear their ugly little heads at f/22—ouch! It took a lot of cloning in Photoshop to tackle the sensor dust spots (and I thought I was fussy about keeping my sensor clean!). In addition to cleaning up the dust spots, I also removed some people in the background and removed the reflection of the softbox that appeared in Mark's sunglasses.

NEUTRAL DENSITY FILTERS TO CONTROL DEPTH OF FIELD

When working in bright light, using the maximum flash sync speed (to maximize out flash power) also forces us to use a small aperture. That small aperture means more depth of field than we might like. There are two ways to force a high-shutter-speed/wide-aperture combination. First is the option to switch to high-speed flash sync—but this dramatically cuts down the power of the flash. The second option is to use a neutral density (ND) filter on the camera's lens.

Image 8-16 shows an image created at 1/$_{250}$ second at f/11 and 200 ISO. At f/11, as you can see, the background is quite sharply rendered. By adding an 8x neutral density filter (**image 8-17**; next page), I was able to go to a much wider aperture (f/4), resulting in a softer, more appealing presentation of the background. This was possible because adding the 8x neutral density filter resulted in a 3 stop reduction in the light entering the lens.

The other way to achieve the desired depth of field is by going to high-speed flash sync. For **image 8-18** (next page), keeping the flash (in a softbox) at the same distance, I shot at 1/$_{2000}$ second and f/4 at 200 ISO. This sent the flash

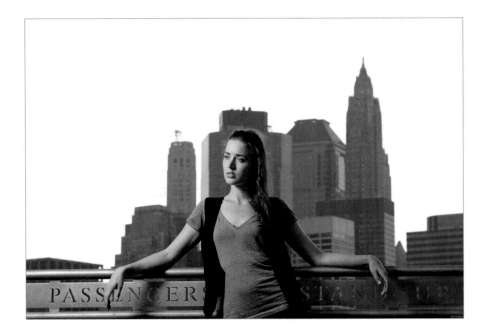

Image 8-16. The image at f/11.

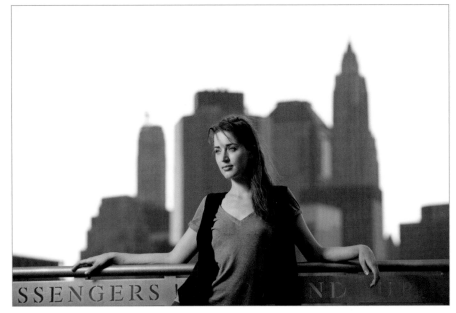

Image 8-17. The image at f/4 (made possible by the addition of an 8x neutral density filter).

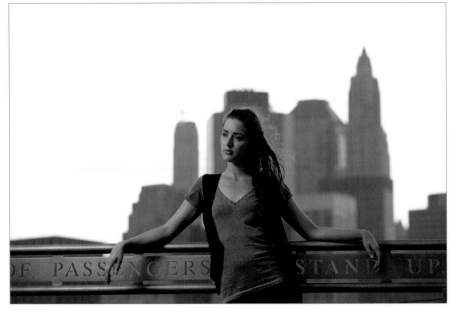

Image 8-18. Switching to high-speed flash sync allowed for the desired depth of field but greatly reduced the flash's output.

into high-speed flash sync mode, switching its output from a high-energy burst of light to a very short period of continuous light. This considerably reduced the flash's output.

The immediate question that will be asked is this: Won't the neutral density filter also cut down the flash's output? Yes, it will—but it will cut the ambient light and flash *by equal amounts*. This means that you don't lose flash power in comparison to the available light. The *balance* stays the same, unlike if you had decided to use high-speed flash sync.

To compensate for the loss of output by going to high-speed flash sync, we would have to move the flash closer. Depending on the composition, this isn't always an option. Adding multiple flashguns would be another option—but it is much more simple to add a neutral density filter.

Finally, **image 8-19** shows you the portrait that I really wanted to produce during that photo session—an image of the sun bursting through the clouds

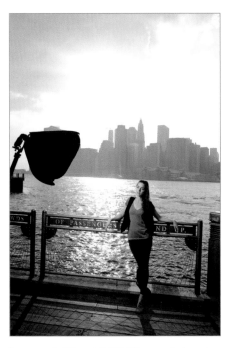

Images 8-19 and **8-20.** The sun is bursting through the clouds. ($^1/_{250}$ second at f/11 and 200 ISO; wireless manual flash at full power –0.7 EV)

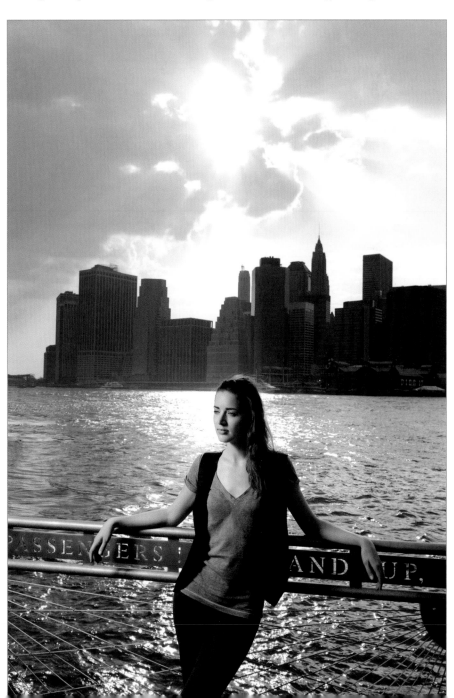

over the Manhattan skyline. My model, Anelisa, was lit by a softbox held aloft at camera left and controlled wirelessly by my on-camera flash.

Here I used manual flash, so my flash exposure was controlled by a combination of aperture, ISO, power setting, and distance. Since I was shooting at full power, the only remaining control for my manual flash exposure was the distance to my subject, so I asked my assistant to move the softbox closer until I had the correct flash exposure.

IN REVIEW

So these are our main options when seeking to overpower brute sunlight:

1. Move the flash closer to the subject.
2. Use direct off-camera flash (without diffusion).
3. Use a more powerful lighting kit that can deliver sufficient power to shoot with diffusion.

The simple formula to overpower the sun is to underexpose the ambient light by 2 stops (or more), then add flash at an exposure equal to the sunlight. We'll also do well (whenever possible) to avoid weird, harsh shadows in the first place by taking care in how we position our subjects.

The only remaining control for my manual flash exposure was the distance to my subject . . .

9. Off-Camera Flash On Location

When I photograph someone on location, I rely on a simple, effective method that will ensure—at the very least—that I will get portraits that will work! In this chapter, we'll look at this method step-by-step.

FIND A GOOD BACKGROUND

The background can be uncluttered and plain and work as a simple backdrop, or it can be a pattern or an interestingly detailed background. In either case, it has to somehow complement your subject.

Images 9-1 and **9-2.** (1/$_{250}$ second at f/4.5 and 200 ISO; manual flash with softbox)

Just as important is to look at the edges of the frame. Carefully look at what you are including and what you are excluding. Avoid things that will detract attention from your subject. If there is a busy background, see if you can compose your photograph in such a way that the background accentuates your subject. Or, perhaps, choose a patterned background with repetitive forms. Throw the background out of focus—at least to some extent.

CONSIDER YOUR LIGHT

For **image 9-3**, I looked for a background where I could position my model, Anelisa, in even light—somewhere with no hard cross-shadows from sunlight and no odd dappled light pattern.

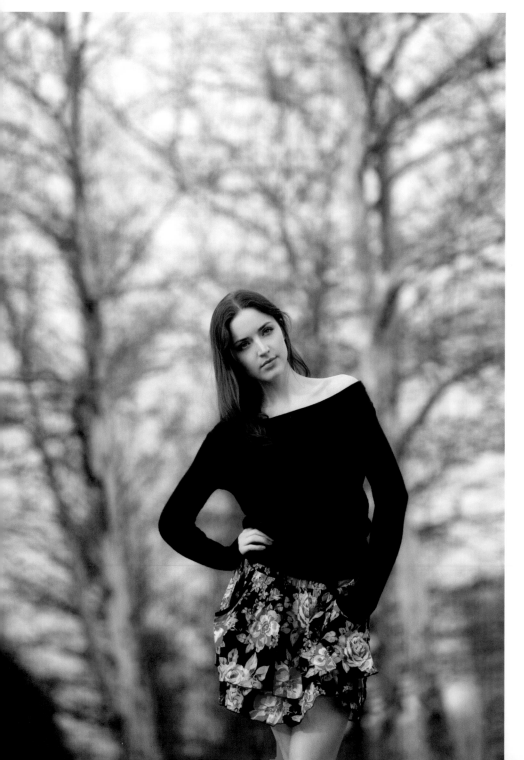

Image 9-3. (1/$_{1000}$ second at f/3.2 and 200 ISO; ambient light only)

Image 9-4 (right). ($^1/_{250}$ second at f/4 and 200 ISO; manual flash with softbox)

Image 9-5 (above). In the image without flash, her eyes are too dark. We were shooting in an alley, so the light was quite top-heavy, causing her features to have unflattering darker areas. This is why off-camera flash was added to the mix.

For my other photographs of Anelisa, I looked for a spot where I could position her against a brighter background. I then found my exposure for the background. Anelisa would have been underexposed if I hadn't used flash, so I added manual flash (set 1 to 2 stops above the ambient light) to expose correctly for her. Placing this flash in a softbox allowed me to control the quality of the light on her. By adjusting the flash exposure, I could balance her exposure with that of the background. For example, in **image 9-1** (the black & white

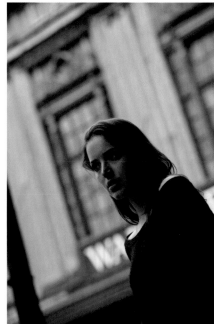

Image 9-6 (left). ($^1/_{250}$ second at f/4 and 200 ISO; manual flash with softbox)

Image 9-7 (above). A test shot without flash to check the background exposure:

image at the start of this chapter), I could have chosen to have my background slightly brighter or darker. If I had decided to use only available light for the photographs I took during the session, I would have had to very carefully consider the quality of light falling on her, as well as how I positioned her. Using flash (with a softbox) gave me a lot more leeway in positioning my light.

POSITION YOURSELF

The background, lighting, and composition must all be balanced in terms of your own position. If you change your position, you will change the composition and the way your subject is depicted in relation to the background. Quite often, changing your position will also change the light you see on your subject. Think of the two extremes as an example: If you are in line with the light falling on your subject, you will have flat/even light. If you stand behind your subject, you have a silhouette. In short, consider how your own position changes the balance in your composition, lighting, and background.

PRACTICAL EXAMPLE:
FLASH ON A RAINY DAY

Scheduling an on-location photo session, we are always left at the mercy of the weather. At this photo session with Jennifer and Chris, the threat of rain turned into a real downpour just before we were about to start. During a phone conversation with them while driving in to the location, we agreed to just go ahead and do the shoot. We would work under the overhangs of various buildings if it should rain.

What gave me the most control over the photo session was the use of off-camera flash. Instead of being limited in the direction I could shoot, I could now use any background that looked good and then add beautiful lighting on my subjects. In **image 9-8**, the colors pop and the skin tones are great. It all looks pretty good with relatively little effort. It just works!

Image 9-8. ($^1/_{250}$ second at f/4 and 640 ISO; TTL flash at –0.3 EV)

Image 9-9 (facing page). ($^1/_{250}$ second at f/4 and 640 ISO; TTL flash at +0.7 EV)

Image 9-10 (right). ($^1/_{500}$ second at f/3.5 and 800 ISO; available light only)

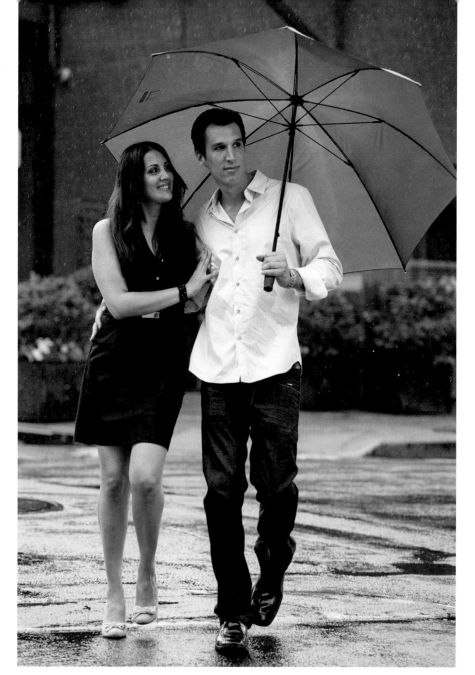

To create **image 9-9**, I used a 24x24-inch softbox with a flashgun. The softbox is easy to carry around, easy to assemble, and lightweight—and the light from it looks really sweet. Furthermore, you can swivel the slave flash sensor around so that the wireless TTL control sensor faces toward the camera. This makes for better reliability in picking up the master flash's control signals. The flashgun (Nikon SB-900) was used in TTL mode, and fired wirelessly by my on-camera flashgun. I disabled the output from my on-camera flash; its sole purpose was to fire the slave flashgun mounted on the softbox.

For the image of the couple crossing the street (**image 9-10**), I didn't even need to use flash. I simply chose the right direction for them to walk toward me. Making sure that the light came from the front produced clean, open lighting on the couple.

Throughout the photo session, my approach to balancing the flash with the ambient light was to underexpose the ambient light to a certain extent, then add TTL flash to bring the subjects' exposure up correctly. **Image 9-11** is the test shot showing how the available light was underexposed at the settings I chose. **Image 9-12** is the final image with addition of TTL flash at –0.7 EV.

There is a fair amount of slack built into shooting this way. With a scenario like this, you can pull the ambient light down to anywhere between –0.7 and –2 EV and expect the TTL flash to give you (close to) correct exposure on the subjects. Then you can adjust the TTL flash exposure up or down based on your assessment of the camera's preview. The light will look good even with some variation in how you balance the flash and ambient.

For **image 9-13**, I asked the couple to show off their dance moves in front of a colorful fence. They were just under the edge of a footbridge, so they were

Image 9-11 (left). ($^1/_{250}$ second at f/5.6 and 640 ISO; ambient light only)

Image 9-12 (right). ($^1/_{250}$ second at f/5.6 and 640 ISO; TTL flash a -0.7 EV)

Image 9-13 (above). ($^1/_{250}$ second at f/4 and 500 ISO; TTL flash a –0.7 EV)

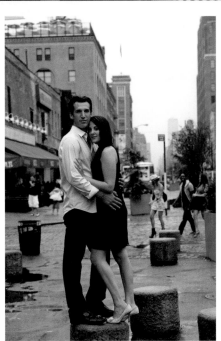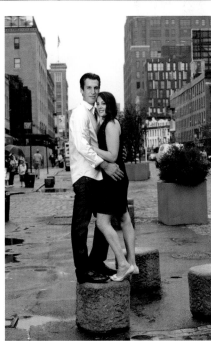

Image 9-14 (left). ($^1/_{250}$ second at f/5.6 and 200 ISO; ambient light only)

Image 9-15 (right). ($^1/_{250}$ second at f/5.6 and 200 ISO; TTL flash at +0.3 EV)

sheltered from the rain—but enough light came from behind them to provide gentle rim lighting. I simply added light from my wirelessly controlled TTL flash on the softbox. Again, positioning them here wasn't just random; I made the decision only after considering where the available light was falling and what would need to be done with the flash.

In **images 9-14** and **9-15**, I wanted to show the effect of the flash—and how the image would have appeared without the flash. As you can see, **image 9-14**

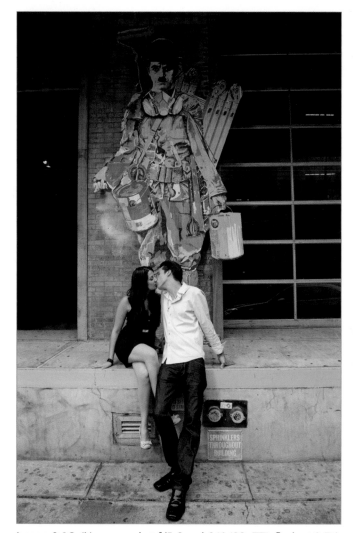

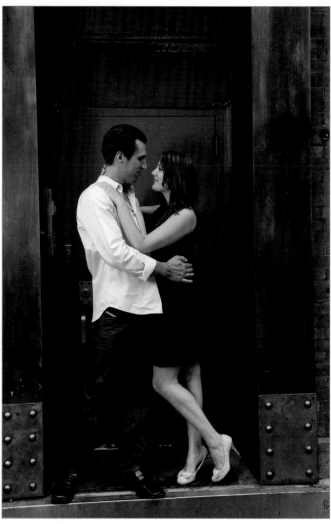

Image 9-16. ($^1/_{250}$ second at f/5.6 and 640 ISO; TTL flash at 0 EV) Image 9-17. ($^1/_{250}$ second at f/5.6 and 640 ISO; TTL flash at –0.3 EV)

was slightly underexposed at the settings I chose. The flash (**image 9-15**) simply cleaned up the light on the couple, giving the photo that extra bit of snap.

I did a few test shots at the start of the session. For the most part, though, the light didn't change much on this rainy day, so I didn't need to do test shots throughout the shoot. I did, however, have to nudge the flash exposure compensation a few times at the start of another set up, so there were one or two test shots for that at various times. The only other times I needed to do test shots were for the sequence where they were sitting on the steps and the sequence against the fence. Both of those scenarios had ambient light that was different from elsewhere.

Images 9-18 and **9-19** show a final image along with a pull-back shot, revealing the placement of the softbox. In this case I had the softbox fairly close to my camera position so I wouldn't get a reflection of the flash in the windows.

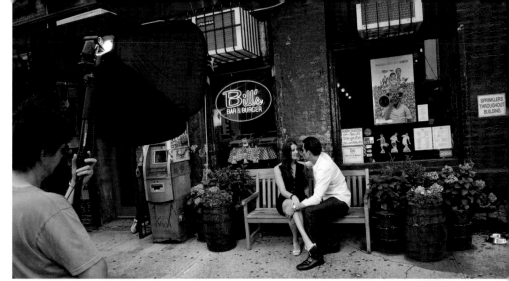

Image 9-18 (below). ($1/200$ second at f/5.6 and 640 ISO; TTL flash at –0.7 EV)

Image 9-19 (right). Pull-back shot for image 9-18.

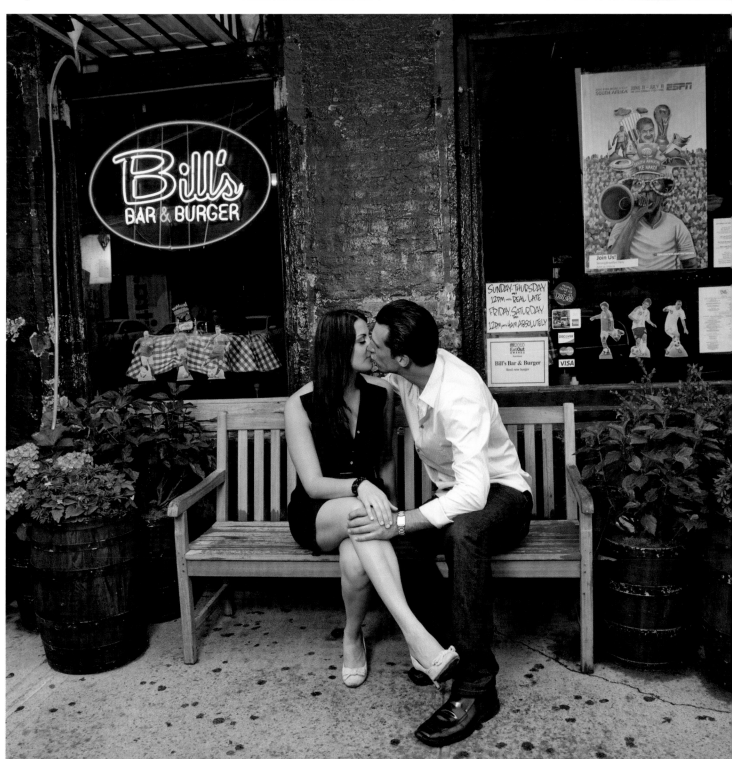

10. Sample Sessions

In this section of the book, we'll look at how these techniques all come together in the situations we might encounter during a variety of photo sessions. We'll pull together all of the things we know about flash photography and light, so that we can work fluidly during a photo session. This way we can confidently create the images we need to for ourselves and for our clients. As you'll see, there is no single, static way of doing things. Happily, these varied techniques help us work in a wide range of situations and give us a wide range of looks in our final images.

MODEL PORTFOLIO IMAGES

Sarah is a model who wanted to extend her portfolio with a variety of images—some including her husband, Mark. We started the photo session at Coney Island, New York, with Sarah in swimwear standing next to Mark at the edge of the beach. From there, it went into more of a lifestyle shoot with the two of them on the boardwalk. Later on, I had Sarah run toward the camera in sportswear, but we were rained out by a massive thunderstorm. We picked up the photo session once again in Battery Park. From there, we moved up to Times Square to photograph a very glamorous-looking Sarah dressed in evening wear.

Sarah is a model who wanted to extend her portfolio with a variety of images . . .

For the swimwear image, I used the powerful Profoto AcuteB 600R lighting kit with 2x3-foot Profoto softbox. This delivers 600Ws of power, enough to match the sun—even with the softbox being used. For the rest of the day, I used a Q-flash in a softbox, which was either held up on a monopod, or placed on a light stand. There is even one image where only available light was used. So it was a mix of lighting equipment, and a mix of techniques.

For **image 10-1**, I've also provided the unretouched image (**image 10-2**) for comparison. As you can see, I removed all the people in the background, along with the rocks and jetty. This was done to simplify the photograph and give it a bit more impact.

I also had to retouch the uneven shadows on Mark's chest where the combination of shadows from the sun and flash created a weird pattern. To be completely rid of the shadows, I would have had to underexpose the ambient light by around 3 stops—but then I'd have lost the beach scene and sky. I could also

Image 10-1 (above). The final swimwear image.

Image 10-2 (right). The original image, with no retouching.

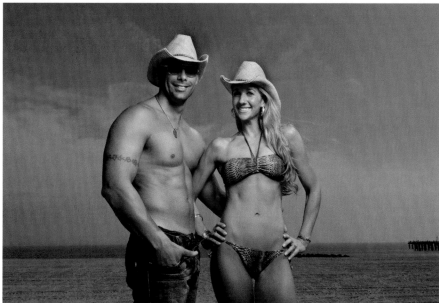

have held large diffusers over them, but that would have required a larger production team. So the post-production work in Photoshop was a compromise required to get the final image without investing more time, equipment, or personnel during the shoot.

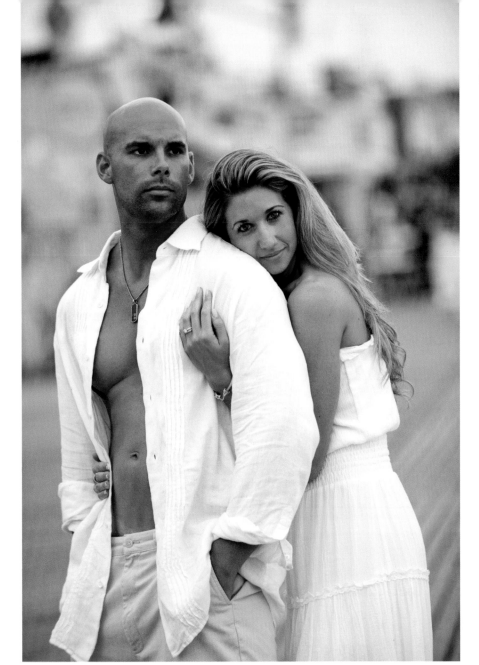

In **images 10-3** through **10-8**, I wanted to show the progression of an idea—how a final image isn't isolated, but usually is part of a sequence . . . even if the sequence isn't shown. I started with a portrait of Sarah hugging Mark (**image 10-3**). For this, I used just the soft, late-afternoon light, diffused by the approaching thunderstorm. It was beautiful light, so no additional light or flash was needed.

Turning around, I saw the sky was darkening rapidly and becoming menacing. As it turned out, about ten minutes later we were dashing for the car as the rain started slamming down on us.

Image 10-4 is a test shot of Sarah against the sky. It is dull; the light on her features is just not great. Her eyes are shrouded in shadow (because they were turned away from the main source of light—the light coming through the clouds). Also, the background clouds were much brighter than my subject. Basically, with natural light alone there was no way to get a correct exposure for Sarah *and* give the sky some detail. With this "in-between" exposure, there's just no drama or punch to the image.

Because I wanted the sky to appear darker and more somber, I underexposed the sky and then added flash from a softbox to camera right. The flash was TTL controlled,

Image 10-4 (right). ($^1/_{250}$ second at f/5.6 and 400 ISO; available light)

Image 10-5 (above). ($^1/_{250}$ second at f/6.3 and 200 ISO; TTL flash)

which made it easy for me to adjust my settings on the fly. This was important because the light was changing so rapidly. The next step was to take a test shot to see how my image would look with Sarah lit with flash and with the camera set to underexpose the sky by more than 1 stop compared to the first test shot. As you can see in **image 10-5**, there's now more drama to the scene.

Again, TTL flash is faster to work with than manual flash in a situation like this. The distinct advantage manual flash offers is a consistency in exposure throughout a sequence of images—which can make post-production

a breeze. When I am working quickly, though, I'll take the speed of using TTL flash over using manual flash. In this case, I wanted to underexpose my sky by more than 1 stop, so I changed both my ISO and my aperture—and my flash exposure followed.

With manual flash, the usual method (in this situation) would be to determine the aperture and ISO for the manual flash, then control the background exposure with the choice of shutter speed. That means there is a chance of hitting a ceiling (the maximum flash sync speed) before your background is dark enough. So you'd have to figure out a shutter speed as a starting point, then work out the flash power setting (at that specific flash-to-subject distance), then figure out the combination of aperture and ISO.

Since TTL flash followed my camera's settings, it was faster for me (in this situation) to just use TTL flash. And remember: a thunderstorm was brewing, so time was critical! Under these circumstances, the possible variations in

Image 10-6 (left). The image straight out of the raw conversion software. ($^{1}/_{250}$ second at f/6.3 and 200 ISO; TTL flash)

Image 10-7 (below). The final cropped and retouched image. ($^{1}/_{250}$ second at f/6.3 and 200 ISO; TTL flash)

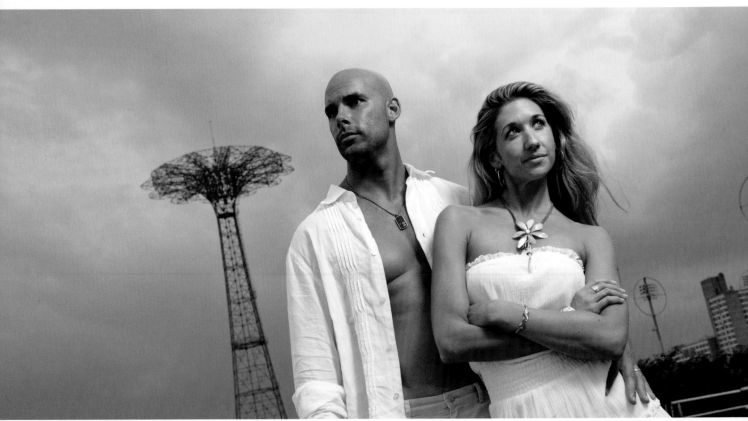

Image 10-8. ($^1/_{250}$ second at f/3.5 and 200 ISO; TTL flash)

TTL flash exposure were something I decided I could live with and fix in post-processing if necessary.

For my next shot, I added Mark and had Sarah lean back into him. **Image 10-6** shows my result straight out of the raw conversion program.

The composition needed to be tightened up, so I went for a more cinematic crop. I also added some slight enhancement in Photoshop to make the image pop even more—and there you have it! The final shot is seen in **image 10-7**.

For my next portrait of Sarah (**image 10-8**), I was still crouched down, shooting up against the brooding light. I used a Q-flash in a softbox off to my right (held up high by my assistant), but this is well within the capabilities of a flashgun and softbox combination. Again, some slight tweaking in Photoshop was used to give the image more punch.

Image 10-9 is an out-take from my session with Sarah. In it, you can see the position of the softbox (on a light stand) relative to my model. In this case I used manual flash, since my subject remained static in relation to the light source. In this case, manual flash just made more sense for the consistency of the exposures. The settings were chosen to expose for the background in a way that I felt retained the mood perfectly of the city scene just after a rain storm in the early evening. I pulled the flash power down to give me just enough light in comparison to that. I metered for the ambient light by pointing my camera towards the ground, and taking a test shot. I opened up my aperture by 1 stop to make the background reflections appear brighter.

Image 10-9. An out-take showing the position of the softbox relative to Sarah. ($^1/_{250}$ second at f/4 and 800 ISO; manual flash)

Image 10-10. ($^1/_{40}$ second at f/2.8 and 1600 ISO; available light, handheld)

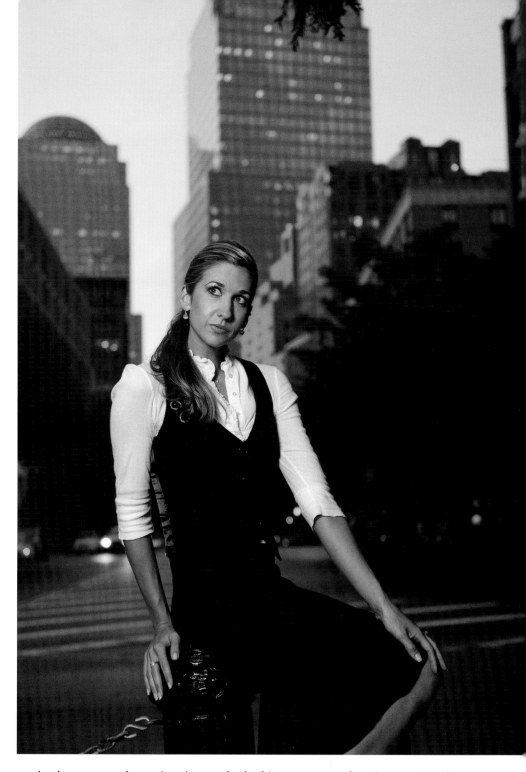

As the sun set, the entire city was bathed in an orange glow (**image 10-10**). Instead of manual flash though (which would have made more sense from a technical standpoint), I decided on TTL flash—because I suspected the security guards in the area would chase us off the moment they became aware of us. It turned out I was right; they stopped us after I had shot about five frames. Shooting with TTL allowed me to set up more quickly than with manual flash—and, in this case, that was more valuable than consistency in flash exposure.

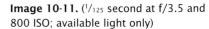
Image 10-11. ($^1/_{125}$ second at f/3.5 and 800 ISO; available light only)

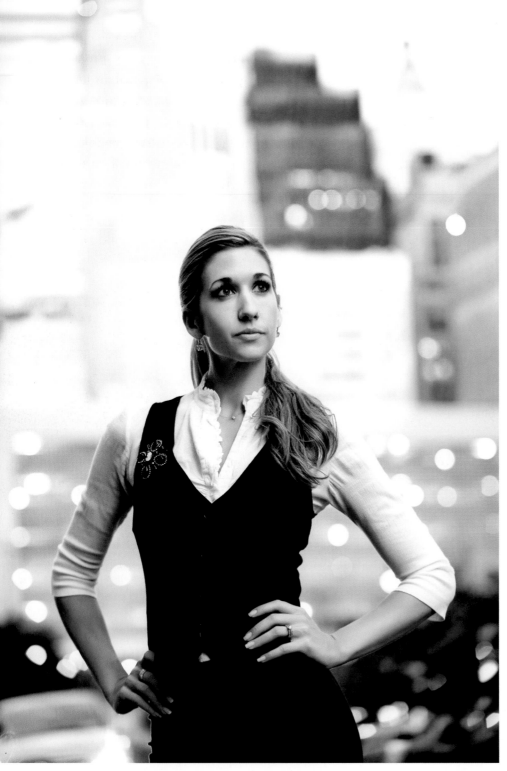

Driving around the corner, I saw an entire street scene bathed in soft light—a perfect backdrop against which to place Sarah (**image 10-11**). My tripod was in the car, but I couldn't set it up in the middle of the (quiet) street, so I shot a series of natural-light, handheld images to ensure I had at least one image that was crisp. After post-processing the image, I ended up preferring this version over the previous one (**image 10–10**).

Finally we hit Times Square in Manhattan. **Image 10-12** shows Sarah in evening attire, still looking strikingly glamorous after a long, long day. I wanted some detail in the brighter areas of the background, and composed my image so that I didn't have too many dark areas directly behind her. Since you can't really use your camera's meter for the neon background in Times Square, it became a matter of taking a few test shots and making camera settings based on your exposure for the background. Setting up the shot was then a matter of posing my model and adding off-camera TTL flash in a softbox.

Image 10-12. ($^1/_{250}$ second at f/4 and 800 ISO; TTL flash)

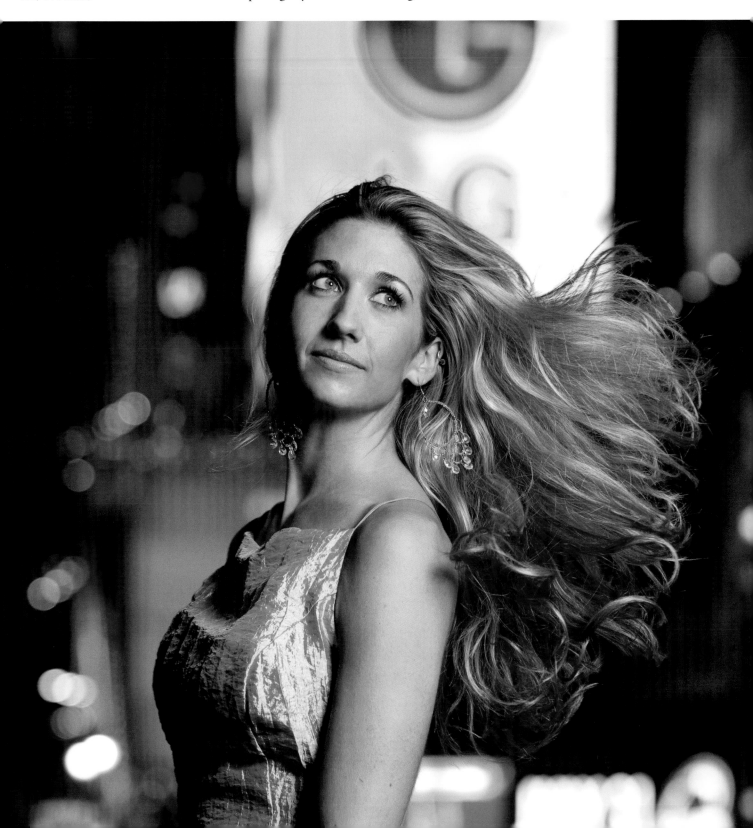

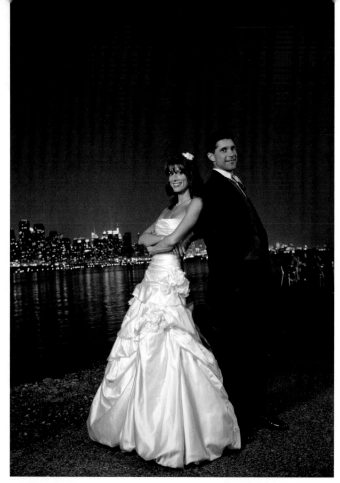

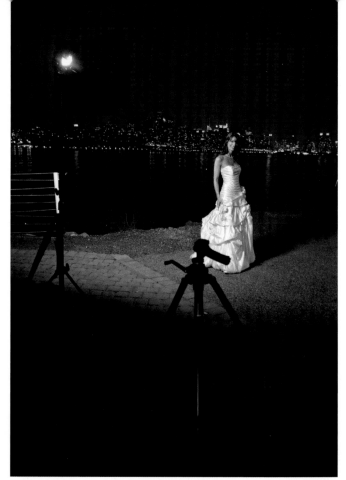

Image 10-13. ($^{1}/_{2}$ second at f/4 and 1000 ISO; TTL flash at +0.3 EV)

Image 10-14. Pull-back shot of image 10-14.

WEDDING PORTRAITS

Night Portraits. While a wedding day is usually quite hectic, with a little leeway in the timeline we might have the opportunity to finesse our lighting of nighttime wedding portraits.

In **image 10-13**, I photographed the couple against the Manhattan skyline in the evening. I positioned them where there was very little ambient light on them (compared to the background). This makes it easier then to add additional lighting in the form of off-camera flash. The next step was getting my exposure for the background. A setting of $^{1}/_{2}$ second at f/4 and 1000 ISO gave me the detail I wanted on the New York skyline. To light the couple, I added a flashgun in a softbox, using it in TTL mode with the flash exposure compensation set to +0.3 EV.

Image 10-14 shows where my tripod was positioned. Since the shutter speed was so slow, I was compelled to use a tripod to keep the image sharp. While flash can freeze movement, the skyline would have been a messy blur if I

had tried to handhold the camera at $^{1}/_{2}$ second. Also, even in a relatively dark area, there was still too much ambient light on the couple for the flash to effectively make them appear sharp at such a slow shutter speed.

Dramatic Skies for More Impact. Often, our background consists of two areas of vastly different brightness levels. One area will be the landscape (the trees, ground, buildings, etc.); the other area is most often the bright sky. Unless you use graduated filters, a subject unto itself, you cannot correctly expose both the areas at the same time.

For my portraits of Stacey and Michael (**images 10-15** and **10-16**), I wanted to show the couple against the brooding sky—but that meant they would be underexposed. Alternately, I could have exposed correctly for them—but then the sky would have been blown out. To balance their exposure level with that of the sky, I needed to add flash. To do this, I had my assistant hold up a (slaved) flashgun in his hand, which I triggered with my on-camera flashgun set as the master flash (with its own

output disabled). **Image 10-15** shows the image with only the ambient light; **image 10-16** is the result achieved by adding flash on the subjects.

By using flash in this way, I was able to bring the detail back in the sky through my exposure settings, making the sky dramatic rather than washed out. In this case, the rocks were also illuminated by the flash to an extent, so they don't appear as a black or unlit background in relation to the couple.

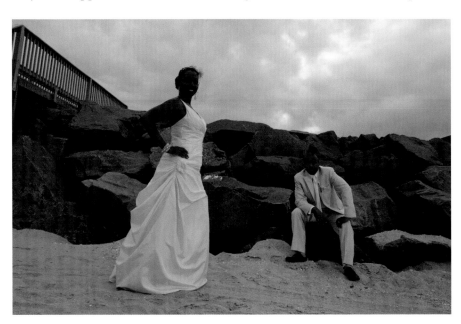

Image 10-15. (1/$_{250}$ second at f/11 and 200 ISO; ambient light only)

Image 10-16. (1/$_{250}$ second at f/11 and 200 ISO; wireless TTL at +1.3 EV)

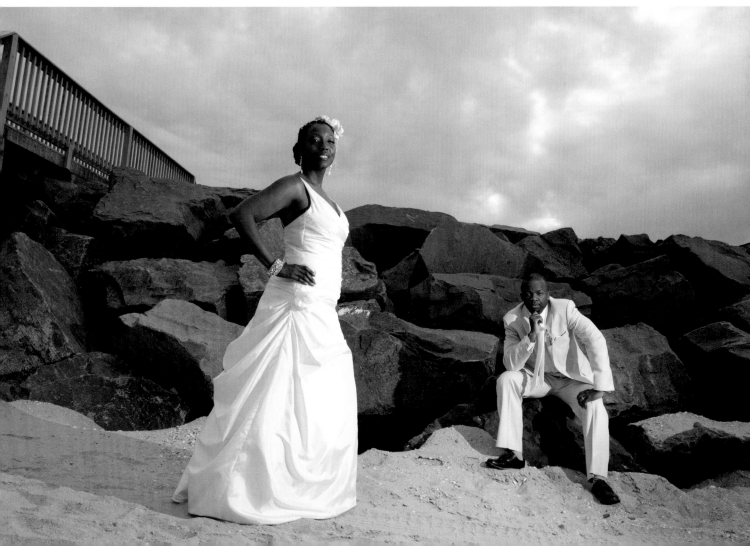

Fireworks. When photographing people with fireworks in the background, we need to drag the shutter. The slower shutter speed will catch the trails of the exploding fireworks.

For **image 10-17**, I had Amy and Kevin stand in an area where there wasn't much ambient light, so that I could light them with flash. My flash exposure was set to expose the couple correctly, but my camera settings were dictated by how I wanted the fireworks to register.

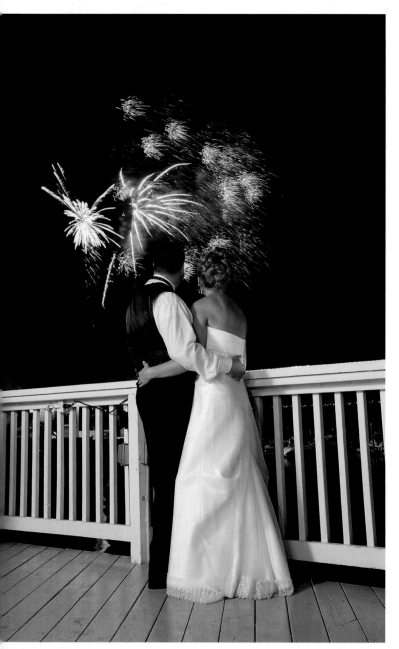

Image 10-17. (1 second at f/6.7 and 400 ISO; manual flash in a shoot-through umbrella)

For my fireworks exposure, which is considered as ambient light, I had to juggle the three controls: shutter speed, aperture, and ISO. Your ISO should be in the 100 to 400 range. You don't want a high ISO when photographing fireworks, since you need a shutter speed slow enough to record the fireworks as streaks of light. This will usually be around 1 second or slower. (So, yes, you will need a tripod.) Checking your camera's preview will tell you whether you need to further adjust your settings. I found that 1 second at f/6.7 and 400 ISO gave me enough well-exposed firework trails. Then I set my flash to an appropriate power level for that exposure. Manual flash was used in this instance, since my subject was in a fixed position relative to my flash. (*Note:* Recording multiple bursts of fireworks by blanking out the frame with a black card is a great idea. This photograph was a single exposure, though.)

Formal Portraits. When photographing the formal photos at weddings, I choose a simple approach that allows me to work fast, and get clean results that work every time. I prefer a fairly flat way of lighting everyone, and I keep the lighting static for all the images—whether I am photographing one person or twenty people. With time usually being a real constraint during the wedding day, there simply isn't the opportunity to play around too much with the lighting. Therefore, I find that a simple, predictable approach works best.

Because I work with off-camera lighting, and everyone is static in relation to the lights, it is simpler and more reliable to work with manual flash. You could work with a flash meter, but I prefer to use the histogram and meter for the brightest relevant tone: the white dress. (Refer back to chapter 5 for more on this technique.)

The flash exposure is chosen for a specific aperture and ISO. We need enough depth of field to keep a small group of faces all in focus; f/5.6 is a good place to start. For the ISO, you'll want to use as low as possible in order to get the best color reproduction and contrast—and as little digital noise as possible. On modern DSLRs, an ISO of 400 gives very good results and can even be considered a low ISO setting.

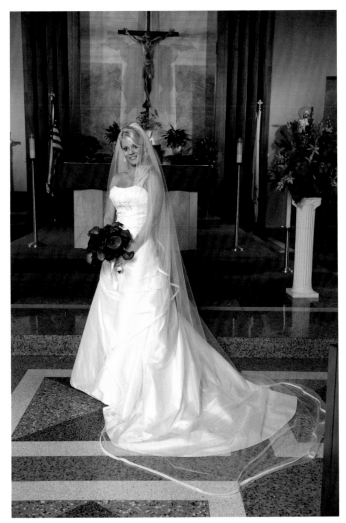

Image 10-18. ($^1/_{100}$ second at f/5.6 and 400 ISO; manual flash)

Image 10-19. ($^1/_{100}$ second at f/5.6 and 400 ISO; available light)

But these settings also need to be chosen in relation to our available light. For **image 10-18** (with flash), **image 10-19** shows only the available light. You can see how much light there was in the background—and that there was a slight amount of available light coming from a window somewhere. I needed to choose a shutter speed at which enough of the background registered, but the light falling on the bride from the window didn't cause an uneven lighting pattern on her. Normally, I would consider $^1/_{100}$ second to be a fairly low shutter speed when hand-holding with available light. In this case, however, the risk of camera shake was nearly eliminated because the flash completely dominated as the light source. This allowed me to work comfortably without a tripod.

Gelling the Flash for Tungsten. Since the lighting in churches is predominantly tungsten (or some other kind of artificial light), I usually gel my flash either with a full or ½ CTS to bring my flash's white balance in line with the existing light. This helps eliminate the grungy-looking orange backgrounds you see in many indoor flash images.

For small groups, up to eight or nine people, I most often just use one flashgun, a Quantum flash, with a 60-inch umbrella (**image 10-20**). This large light source gives me even enough coverage for a small group. When using just the one light (and 60-inch umbrella), I keep the light off-center from my position—but not by much more than two or three feet, since I want even coverage for everyone in the group. With larger groups, I use two of these setups, spaced evenly on either side of me.

I prefer using the Quantum flashguns. They are workhorses that never seem to overheat—I can just keep on shooting without a thought to them. You can certainly achieve similar results with a speedlight, but you might have to fire at a slightly slower, steadier rate. Since a speedlight would most likely be working at (or close to) full power here, there is a chance of overheating. You would also have to fire more slowly to make sure that the flash recycled properly between shots.

Image 10-20 (right). A 60-inch umbrella on a light stand.

Image 10-21 (below). A group illuminated with two 60-inch umbrellas placed to either side of the camera.

More On Umbrellas

I use bounce umbrellas with black backings rather than white shoot-through umbrellas. Bounce umbrellas are slightly more efficient than shoot-through models when working in areas where there is little chance of the spill light from the shoot-through umbrella bouncing around the room (in other words, in areas where the light reflected from the shoot-through umbrella doesn't add to the final amount of light). In a smaller room or studio with white walls, the shoot-through umbrella would work like a charm—but in a church or larger venue, I want the light more efficiently used.

Then there is another huge benefit in *not* using a shoot-through umbrella. With a shoot-through umbrella, if I stand back too far, I run the risk of getting lens flare. With a bounce umbrella, the spill light is minimized, so I have much less chance of getting lens flare. This becomes especially important while shooting quickly and not concentrating on shielding my lens properly—even while using a lens hood.

The radio transmitter I use is the industry-standard Pocket Wizard (in this case, the Plus II). As mentioned earlier, I don't need TTL metering here—and I actually don't want it. I need the simplicity and predictability of manual flash.

Image 10-21 shows a group photographed using two Q-flashes, each with a 60-inch umbrella. I place the two light-stands flanking me at a distance of about eight or nine feet. Since the umbrellas are so big, there is considerable overlap in coverage and the light is quite diffuse, resulting in an even spread. You can contrast this against the single light used in **image 10-18**; here, there just isn't a sharply defined shadow.

I set the flashguns to just under full power ($\frac{1}{3}$ stop under full power), which allowed them to recycle a little more quickly than a full-power setting. This gave me a more consistent exposure from image to image, even when I shot a little too fast and didn't time my shots evenly.

By setting my flashguns to a specific power level every time I start with the formal portraits indoors, I have become accustomed to approximate settings when I set my flashgun (with a 60-inch umbrella) at a certain distance from where I will pose the groups. That setting (around f/5.6 at 400 ISO for my normal working distance) is where I start. Then I do a quick test shot of the bride's dress and see how my histogram shape falls. Based on that, I will make any needed adjustments to my camera settings or even pull up the power on the flashgun(s) a touch.

This really is something you can set up and test beforehand and get used to it. With manual flash, you will get the same exposure every time when you have a specific distance and your flash set to a specific power. That's the beauty of manual flash: it's predictable. Since the flash emits a specific amount of light every time, and since the flash is on a stand (at a constant distance to your

This gave me a more consistent exposure from image to image . . .

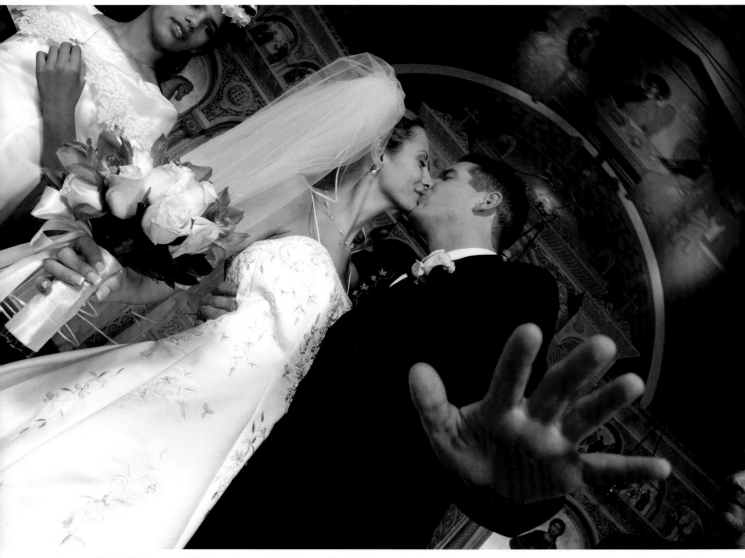

Image 10-22. With manual flash and your light(s) at a fixed distance to the subject, you can change your position without affecting the exposure.

subject), your flash exposure will be consistent regardless of your position—*so you can even move around without affecting the flash exposure.*

Image 10-22, an off-beat photograph of the bride and groom kissing, was a grab shot. While I was on my knees in front of the bride, adjusting her dress, the groom leaned in for a kiss. I grabbed my camera—and as I lifted it to my eye, the groom playfully tried to block my shot. And there it is! Since my lights were set up and my exposure was calculated for the manual off-camera flash, the settings remained consistent despite my close proximity to them. *My distance to the subject had no influence here.*

ARTIST PORTRAITS

The Modern Gypsies (www.modern-gypsies.com) are performance artists based in New York. I worked with them on a few photo shoots to expand their portfolio for their web site. Shooting in different situations required different approaches to the lighting.

For **images 10-23** and **10-24**, I wanted to photograph one performer waving massive fabric banners around in the air. We were on the rooftop of a building in Brooklyn, and the direction I had to shoot in was decided by the direction of the wind. This meant I had to shoot into the sun. I had to set an exposure where I didn't blow out most of the sky; I wanted to retain the detail in the clouds

and sky. I also knew that the fabric banners would be okay in terms of exposure since they would be back-lit. However, I had to get some light onto Mike—the alien-looking performer in green and pink. (He was a super-nice guy—don't be fooled by the looks!) This meant I had to add flash to the scenario.

I knew that the Q-flash in a soft-box would simply not pump out enough light; I had to get direct flash on him. I even took off the diffuser disc over the front of the Q-flash in order to get the exposure necessary. I decided to stay with manual flash to get full power. I needed everything the flash was capable of, so this was not the time to be fooling around with TTL flash and flash exposure compensation. I had my assistant, Jessica, stand behind me on a low wall. Since the banners would sweep past us, I didn't want to be hampered by worrying about a light-stick constantly getting entangled. So the flash was from the camera's point of view, but higher. (*Note:* For the pull-back shot, **image 10-25**, I stepped to the side so that I could include my assistant in the photo.)

With manual flash, the aperture, ISO, flash power, and subject-to-light distance are locked in relation

Image 10-23 (top). (1/$_{250}$ second at f/13 and 100 ISO; manual flash)

Image 10-24 (middle). (1/$_{250}$ second at f/14 and 200 ISO; manual flash)

Image 10-25 (bottom). Pull-back shot for images 10-23 and 10-24.

to each other. I set the flash to maximum power because I knew I would have to use a small aperture (at a low ISO) to have the sky properly exposed. Then it was just a matter of getting close enough to produce correct flash exposure on my subject. Could I have done this with just a bare speedlight? Absolutely. I didn't need my flash to spread over a wide area. I could have zoomed in with a flashgun to just light the performer.

I also photographed Bird Girl in a park (**images 10-26** and **10-27**). I wanted to create a sense of freedom by placing her against a backdrop unencumbered by urban clutter—just trees and open space. To do this, I lay down on the ground and shot up toward where she was standing atop a low wall.

As with previous examples in this book, the technique was quite easy. I got a basic ambient exposure that was close to correct, then added flash to clean up the light. In this case, I decided to use wireless TTL flash with a slaved flash in a softbox to camera right, just a little past Bird Girl. As a result, the fill flash comes in from slightly behind her, not from somewhere close to the camera's point of view. Since the flash was just fill light to make the photo pop a bit, my flash exposure compensation was turned down to –2 EV.

Image 10-26. ($^1/_{250}$ second at f/3.2 and 500 ISO; TTL flash at –2 EV)

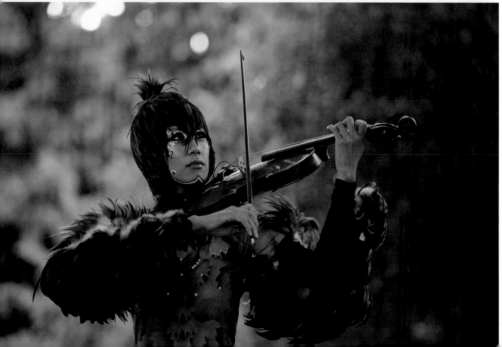

Image 10-27. ($^1/_{250}$ second at f/3.2 and 500 ISO; ambient light only)

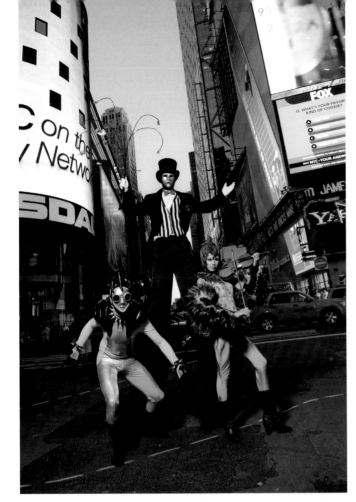

Image 10-28 (above left). ($^1/_{200}$ second at f/5.0 and 800 ISO; TTL flash at +0.3 EV)

Image 10-29 (above right). ($^1/_{200}$ second at f/5.0 and 800 ISO; ambient light only)

Image 10-30 (right). A pull-back shot showing the flashgun in a softbox, held up on a monopod.

Heading to Times Square in the early evening, I met up with three members of the Modern Gypsies. Before they arrived, I needed to decide on a basic exposure that would encompass the flashing of the neon signs and the rapidly falling evening light. I did this by guessing an approximate exposure, then double-checking it on my camera's LCD screen.

Image 10-31. (¹/₂₀₀ second at f/4.0 and 800 ISO; TTL flash at –0.3 EV)

Image 10-32. (¹/₂₀₀ second at f/4.0 and 800 ISO; TTL flash at –0.3 EV)

Image 10-33. (¹/₂₀₀ second at f/3.5 and 500 ISO; TTL flash at –1 EV)

Image 10-34. (¹/₂₀₀ second at f/3.5 and 500 ISO; ambient light only)

A scenario like this is where TTL flash really shows its strength. With the thronging crowd we were moving through and the stilt walker's erratic movements (**image 10-28**), we weren't always sure of having the same distance between our light and the subject. This constant change in distance would have made it tricky to use manual flash. I needed the help of the TTL flash technology to get me close to correct exposure in each frame.

The technique used here should be obvious and even self-explanatory by now. I found an exposure for the background, then added flash. The method is simplicity itself when the subject is darker than the surrounding areas in the photograph.

FASHION PORTRAITS

Let's look at more examples—in this case, images that span the fashion and portrait genres. For **image 10-35**, I used wireless TTL flash. As with a number of the other examples shown here, I had my on-camera flashgun (the master) pointing to the slave flashgun mounted on a softbox. The master flash's main output was disabled; it was only used to control the slave. I needed line of sight for the master to control the remote flash.

I wanted a little bit of detail in the sky, and this dictated a small aperture at a low ISO. Shooting at the maximum flash sync speed maximized the output from the flash, but the softbox did pull it down a bit. To compensate, I moved

Image 10-35. (1/$_{250}$ second at f/10 and 200 ISO; TTL flash at +1.33 EV)

Image 10-36. ($^1/_{200}$ second at f/5.6 and 200 ISO; manual flash)

the softbox close enough to give me the $^1/_{250}$ second at f/10 and 200 ISO exposure needed for this image. Fortunately, I planned to crop out the buildings on the left, since they didn't add much to the final square image I had in mind. As a result, it wasn't a problem to move the softbox within shot. (*Note:* I could also have used a more powerful flashgun, two flashguns in tandem, or a bare flash to attain the needed power. These approaches would have allowed me to

move the flash out of shot, but the light, especially from the direct flash, would have looked different.)

Metal reflects a lot of light, causing the camera to think there is more light from the flash than there actually is. Therefore, I had my flash exposure compensation set to +1.33 EV to compensate for the brighter tonality of the scene. The rest of the success of the image depended on Catherine, a fantastic model, and the great architect who designed the sundial.

In **image 10-36**, the leading lines of the elevated train tracks, the pavement, and the cars all helped to produce a dynamic composition—as did the crazy angle my model, Julia, created with her body. For this image, the lighting was with a softbox and a flashgun, held at a 45 degree angle to camera right. The flashgun was set to manual, to give me an exposure of f/5.6 at 200 ISO. This balanced

fairly well with the available light. The flash was metered with a Sekonic flash meter, giving me the correct flash exposure for those settings and the specific distance the light was going to be held at in relation to our model. (The other variable being, of course, the flash's power setting.)

The success of a portrait session relies not only on the personality of the model, but also the lighting and a complementary background. During my photo session with April (**image 10-37**), I decided to use the receding perspective of black columns outside a storefront. I wanted a neutral background so that the photograph was more about April's personality than the environment.

For this shot, I used Profoto AcuteB 600R lighting, but a flashgun and softbox would have worked perfectly, too. Since the Profoto kit isn't TTL capable, I used manual flash metered with a flash meter.

Image 10-37 (above left). (1/₂₅₀ second at f/4.5 and 400 ISO; manual flash)

Image 10-38 (above right). A pull-back shot showing the setup for image 10-37.

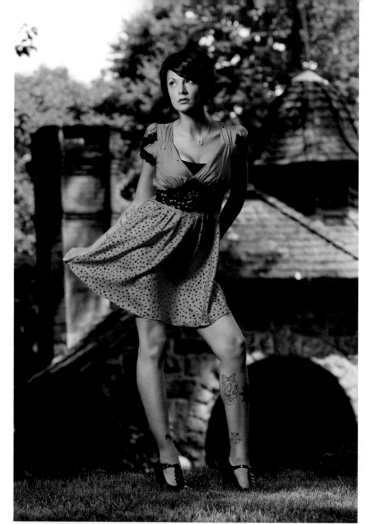

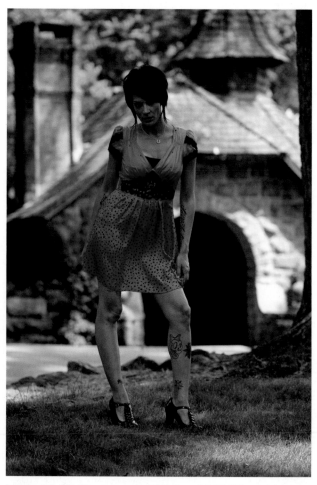

Images 10-39 and **10-40 (left, top and bottom).** ($^1/_{250}$ second at f/5.6 and 200 ISO; TTL flash at –0.3 EV)

Image 10-41. ($^1/_{250}$ second at f/5.6 and 200 ISO; ambient light only)

During my photo session with Jessica (**images 10-39** through **10-43**), I positioned her in shade under some trees. But I took great care in not having any uneven dappled light on her, as can be seen in the comparison photograph where the flash was disabled (**image 10-41**). I used wireless TTL flash for the entire session. My master flashgun's output was disabled; it was used only to fire a slave flash held with a softbox.

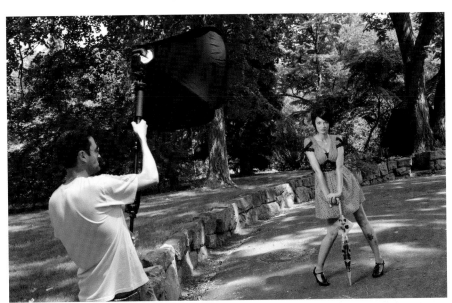

Image 10-42 (below). ($^1\!/_{250}$ second at f/5.6 and 200 ISO; TTL flash at –1 EV)

Image 10-43 (right). Pull-back shot showing the setup for image 10-41.

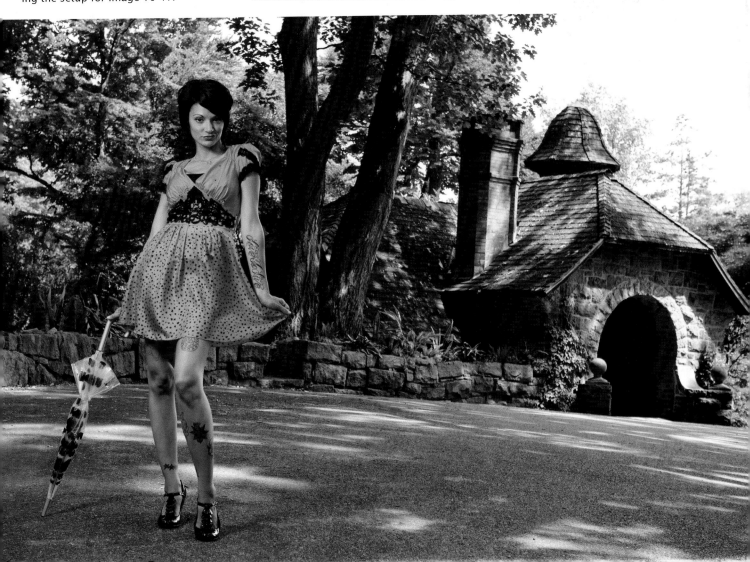

MIX 'N' MATCH TTL AND MANUAL FLASH

So far, all the setups in this book have used either manual flash or TTL flash. What happens when we mix it up, combining TTL and manual flash in a single photo? For **images 10-44** through **10-46**, model Carrie was lit by wirelessly controlled TTL flash (via a flashgun in a softbox). The background, on the other hand, was lit by direct off-camera manual flash, triggered by a Pocket Wizard Plus II unit.

I used a tall light stand in this setup; since Carrie was standing on a ledge, I needed more elevation than a smaller stand could give me. The light stand

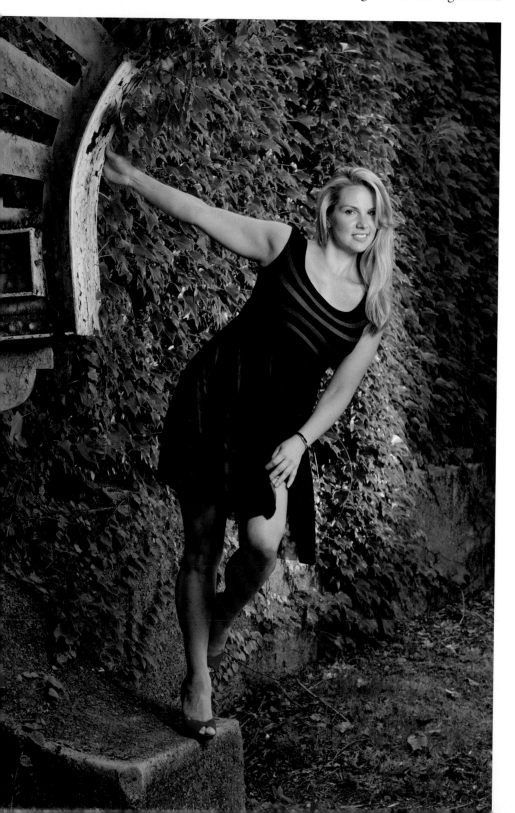

Image 10-44. The final image, with the TTL flash (on the model) and the manual flash (on the background).

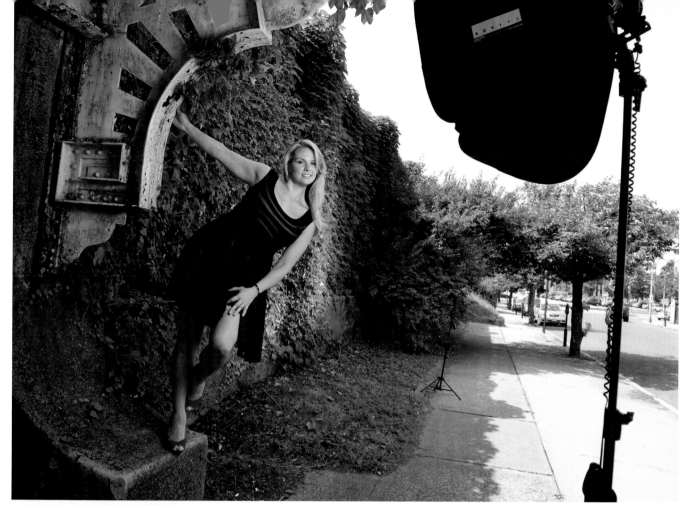

Image 10-45. The setup for image 10-44.

needed to lift the softbox to a good height, about a 30 degree elevation above her face. It also needed to be sturdy enough not to be easily blown over in the wind when the softbox was mounted. The light-stand in the background was smaller, since it just needed to hold up a single flashgun (with a battery pack) to illuminate part of the background.

Why did I choose wireless TTL flash to light the model, but use manual flash for the background? Because I could. It all works.

Image 10-46. The image with only the TTL flash (on the model) fired. The manual flash on the background was disabled by switching off the Pocket Wizard.

Conclusion

I trust that this book has helped to introduce you to the flexibility and freedom of off-camera lighting. Or, if you were already experienced in this, that it has helped to bring a few ideas together for you. To conclude, I want to take us back to the foreword by Chuck Ärlund and remind you to get out there, play, and practice. Have fun and learn. The beauty of photography is that there is no end to the learning curve. It's a life-long endeavor. Enjoy the trip! I'd also like to invite you to visit my web site (http://neilvn.com/tangents/), where I'm continually posting new articles and replying to any questions.

Index

OTHER BOOKS FROM

Amherst Media®

Available Light Glamour Photography

Joe Farace teaches you simple strategies for harnessing natural, man-made, and mixed lighting to create beautiful, sensuous images in any location. *$29.95 list, 7.5x10, 160p, 200 color images, order no. 1973.*

Flash Photography

Barry Staver shows you how to approach lighting with flash in a clear, systematic way that produces outstanding results. Includes easy-to-implement studio and location techniques for photographers of all experience levels. *$29.95 list, 7.5x10, 160p, 340 color images, order no. 1974.*

The Flash Stick

Rod and Robin Deutschmann teach you how to craft and use a simple and suprisingly inexpensive device called a flash stick to position a flash exactly where it's needed—without an assistant. *$19.95 list, 7.5x10, 96p, 210 color images, order no. 1975.*

Backdrops and Backgrounds
A PORTRAIT PHOTOGRAPHER'S GUIDE

Ryan Klos' book provides an eye-opening guide to selecting, lighting, and modifying man-made and natural backdrops to create standout portraits. *$29.95 list, 7.5x10, 160p, 220 color images, order no. 1976.*

Photographing Dogs

Lara Blair presents hard-won business strategies for building a successful, stand-out dog portraiture studio. You'll learn to attract clients and work with canines in the studio and on location. *$29.95 list, 7.5x10, 160p, 276 color images, order no. 1977.*

Lighting for Product Photography

Allison Earnest shows you how to select and modify light sources in order to capture the color, shape, and texture of an array of products. *$29.95 list, 7.5x10, 160p, 195 color images, order no. 1978.*

Posing for Portrait and Glamour Photography

Joe Farace provides essential strategies for idealizing your every portrait subject and creating flattering, evocative photographs that sell. *$29.95 list, 7.5x10, 160p, 260 color images, order no. 1979.*

500 Poses for Photographing Groups

Michelle Perkins provides an impressive collection of images that will inspire you to design polished, professional portraits of small and large groups. *$34.95 list, 8.5x11, 128p, 500 color images, order no. 1980.*

Just Available Light
TECHNIQUES FOR DIGITAL PHOTOGRAPHERS

Rod and Robin Deutschmann show you how to capture high-end images of portrait and still-life subjects using the light that surrounds you. *$19.95 list, 7.5x10, 96p, 220 color images, order no. 1981.*

Beautiful Beach Portraits

Mary Fisk-Taylor and Jamie Hayes take you behind the scenes on the creation of their most popular images, showing you how each was conceived and created. From dramatic to light-and-breezy, this book has it all! *$27.95 list, 7.5x10, 128p, 180 color images, order no. 2025.*

THE ART AND BUSINESS OF HIGH SCHOOL
Senior Portrait Photography, *2nd ed.*

Ellie Vayo provides critical discussions on marketing and business tips that new and seasoned senior portrait photographers will find indispensable. *$29.95 list, 7.5x10, 160p, 340 color images, order no. 1983.*

Figure Photography

Billy Pegram provides a unique and comprehensive approach to conceptualizing and designing high-end commercial and fine-art figure portraits. Leave no aspect of figure photography to chance. Master the art with the tips in this book. *$29.95 list, 7.5x10, 160p, 300 color images, order no. 1984.*

Step-by-Step Lighting for Studio Portrait Photography

Jeff Smith teaches you how to develop a comprehensive lighting strategy that truly sculpts the subject for breathtaking, dimensional results. *$29.95 list, 7.5x10, 160p, 275 color images, order no. 1985.*

Creating Stylish & Sexy Photography
A GUIDE TO GLAMOUR PORTRAITURE

Chris Nelson provides the information you need to best interact with your every subject and tailor your technical approach to bring out the sensual side in your every client—beautifully. *$19.95 list, 7.5x10, 96p, 200 color images, order no. 1986.*

Modern Bridal Photography Techniques

Get a behind-the-scenes look at some of Brett Florens' most prized images—from conceptualization to creation. *$29.95 list, 7.5x10, 160p, 200 color images, 25 diagrams, order no. 1987.*

Create Erotic Photography

Richard Young shows you how to create expert, evocative, and sexy portraits that require minimal gear and an array of easy-to-learn, versatile lighting and posing techniques. *$27.95 list, 7.5x10, 160p, 200 color images, 25 diagrams, order no. 1988.*

Photographing the Child

Jennifer George shows you how to harness the power of natural light, take advantage of myriad locations, and use a fun, kid-friendly photographic approach to bring out every child's best in front of the lens. *$27.95 list, 7.5x10, 160p, 225 color images, order no. 1989.*

Location Lighting Handbook for Portrait Photographers

Stephanie and Peter Zettl provide simple, effective techniques for creating elegant and expressive lighting for your subjects in *any* location. *$27.95 list, 7.5x10, 160p, 200 color images, order no. 1990.*

500 Poses for Photographing Infants and Toddlers

Michelle Perkins shares a host of top images from the industry's best children's and family photographers to help you conceptualize and deliver the perfect kids' poses. *$34.95 list, 8.5x11, 128p, 500 color images, order no. 1991.*

Storytelling Techniques for Digital Filmmakers

Ross Hockrow shows you how to engage viewers through the careful use of shot sequences, perspective, point of view, lighting, and more. *$19.95 list, 6x9, 128p, 150 color images, order no. 1992.*

Commercial Photographer's Master Lighting Guide, *2nd ed.*

Robert Morrissey details the advanced lighting techniques needed to create saleable commercial images of myriad subjects. Detailed lighting diagrams help ensure easy learning. *$27.95 list, 7.5x10, 128p, 300 color images, order no. 1993.*

Professional HDR Photography

Mark Chen shows you how you can achieve extraordinary detail and brilliant color photographs of any subject using high dynamic range shooting and postproduction techniques. *$27.95 list, 7.5x10, 128p, 250 color images, order no. 1994.*

Photographing Families

Tammy Warnock and Lou Jacobs Jr. demonstrate the lighting and posing skills needed to create professional-quality portraits of families and children of all ages in a wide range of settings. *$27.95 list, 7.5x10, 128p, 180 color images, order no. 1997.*

Set the Scene

With an inspiring array of techniques and images from nearly a dozen top pros, Tracy Dorr shows you how using props can inspire you to design highly creative, storytelling, customized portraits. *$27.95 list, 7.5x10, 128p, 320 color images, order no. 1999.*

By the Same Author . . .

On-Camera Flash TECHNIQUES FOR DIGITAL WEDDING AND PORTRAIT PHOTOGRAPHY

Neil van Niekerk teaches you how to use on-camera flash to create flattering portrait lighting in the studio, outdoors, and on location. *$34.95 list, 8.5x11, 128p, 190 color images, index, order no. 1888.*

Direction & Quality of Light

Neil van Niekerk shows you how consciously controlling the direction and quality of light in your portraits can take your work to a whole new level. *$29.95 list, 7.5x10, 160p, 194 color images, order no. 1982.*

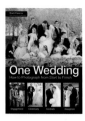

One Wedding

Brett Florens takes you through the photography process—hour by hour—for one entire wedding, showing you how he met a couple's photo needs—from the engagement shots, to the ceremony, to the reception, and beyond! *$27.95 list, 7.5x10, 128p, 375 color images, order no. 2015.*

Step-by-Step Lighting for Outdoor Portrait Photography

Jeff Smith presents you with his no-nonsense approach to outdoor lighting, showing how you can easily produce great portraits all day long. *$27.95 list, 7.5x10, 128p, 275 color images, order no. 2009.*

Master Lighting Guide for Portrait Photographers, *2nd ed.*

Christopher Grey shows you how to master traditional lighting styles and use creative modifications to maximize your results. *$27.95 list, 7.5x10, 160p, 350 color images, order no. 1998.*

The Right Light

Working with couples, families, and children, Krista Smith shows how using natural light can allow you to bring out the best in every subject and produce highly marketable images. *$27.95 list, 7.5x10, 128p, 250 color images, order no. 2018.*

Photographing the Female Form with Digital Infrared

Laurie Klein shows you how to develop a concept, find locations, pose the model, and use natural light to create stand-out digital infrared portraits. *$27.95 list, 7.5x10, 128p, 180 color images, order no. 2021.*

Dream Weddings

Celebrated wedding photographer and photo-educator Neal Urban shows you how to capture more powerful and dramatic images at every phase of the wedding photography process. *$27.95 list, 7.5x10, 128p, 190 color images, order no. 1996.*

Elegant Boudoir Photography

Jessica Lark takes you through every step of the boudoir photography process, showing you how to work with clients and conceptualize and design sensual portraits that engage and delight viewers. *$27.95 list, 7.5x10, 128p, 230 color images, order no. 2014.*

Light a Model

Billy Pegram shows you surefire techniques for creating edgy, fashion-inspired looks with lighting, culminating in images of models (or other photo subjects) with a high-impact editorial style. *$27.95 list, 7.5x10, 128p, 190 color images, order no. 2016.*

Magic Light and the Dynamic Landscape

Jeanine Leech helps you produce outstanding landscape images of any scene, using the time of day, weather, composition, and more for enhanced appeal. *$27.95 list, 7.5x10, 128p, 300 color images, order no. 2022.*

Shoot to Thrill

Acclaimed photographer Michael Mowbray shows you how speedlights can rise to any photographic challenge—allowing you to produce stunning wedding and portrait images in the studio or on location. *$27.95 list, 7.5x10, 128p, 220 color images, order no. 2011.*

Shaping Light

Glenn Rand and Tim Meyer explore the critical role that light modifiers play in producing professional images of any subject, ensuring maximum creative control and smart decisions at every turn. *$27.95 list, 7.5x10, 128p, 200 color images, order no. 2012.*